POSTCARD HISTORY SERIES

Asbury Park

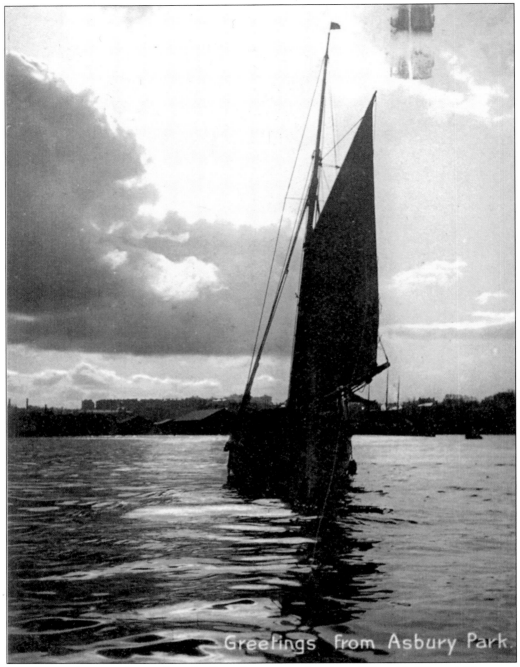

Greetings from Asbury Park.

As always, I dedicate this book with all my love to my four beautiful and brilliant children and their spouses, and to my two beautiful and brilliant grandchildren. Thank you for being such a big part of my life. I love you all.

To Carol, who remembers Asbury Park in its glory days—enjoy. And to our daddy, who ran the Berkeley for many years.

To my beloved Kevin and our buddy Sonny—the Jeff and the Flamingo cards are for you.

POSTCARD HISTORY SERIES

Asbury Park

Shirley Ayres

ARCADIA
PUBLISHING

Published by Arcadia Publishing
Charleston, South Carolina

Printed in the United States of America

Library of Congress Catalog Card Number: 2004116585

For all general information contact Arcadia Publishing at:
Telephone 843-853-2070
Fax 843-853-0044
E-mail sales@arcadiapublishing.com
For customer service and orders:
Toll-Free 1-888-313-2665

Visit us on the Internet at www.arcadiapublishing.com

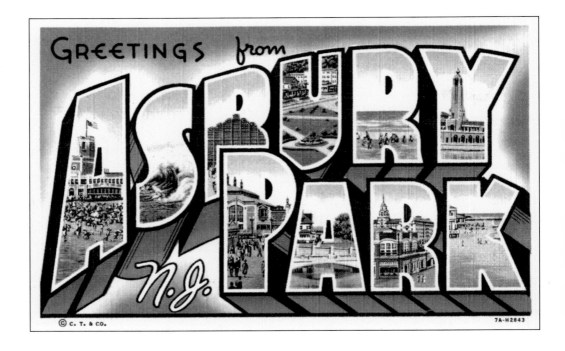

CONTENTS

ACKNOWLEDGMENTS

Many thanks go to the Asbury Park Public Library staff for their help and patience while gathering information for this book: Robert Stewart (director), Charlene Jordan, Patricia LaSala, Wanda Wyckoff, Linda Keane, Lauren Lowdermilk, and LaSeana Scurry.

Also, a very special thank-you goes to Malakia Oglesby for teaching me how to use the new scanner and for cleaning up all my scanning messes. You're the greatest.

Special thanks go to the following knowledgeable people: Ellis Gilliam for all of his Asbury Park knowledge that he so generously imparts to me whenever I ask (and I ask a lot); Thomas Gardner, historian and past exulted ruler, and Karl Lachenauer of the Asbury Park Benevolent and Protective Order of Elks Lodge No. 128; James Grabe and Bob Pinnell for their help in learning about the beautiful and historic armory building; Robert Weldon, postmaster of the Asbury Park Post Office, for all his wonderful pictures and historical documentation on the building of the new post office and the dates of the former post offices; and Gary Crawford for his vast knowledge of the *Morro Castle*.

All postcards are the property of the Asbury Park Public Library. Permission has been obtained for them to be used in this book.

The numerous binders of newspaper articles and other gatherings, lovingly preserved by Ellis Gilliam for the Asbury Park Public Library's research department, were a constant source of amazement and wonderful information to me.

Sources used to create this book include Asbury Park city directories; *Asbury Park*, by Helen-Chantal Pike; *Ocean Grove*, by Wayne T. Bell; *Around Deal Lake*, by Marie A. Sylvester; *Trolleys in the Coast Cities*, by Joseph Eid; and *History of Monmouth County, New Jersey*, by Franklin Ellis.

INTRODUCTION

The postcards bought in and sent from Asbury Park from the late 19th century up to current times recount the history of one of New Jersey's most popular summer resorts. Founder James Adam Bradley carved a thriving business district out of sand dunes and pine forests. Vacationing in Ocean Grove just after the Civil War, he saw the potential for greatness in the almost empty space just north of the Methodist retreat.

By the 1890s, Asbury Park, named for the Methodist bishop Francis Asbury, was a thriving city for both businesses and vacationers. Hotels were everywhere, especially at the beachfront. The wood-framed luxury hotels suffered tremendous losses from several terrible wind-driven fires that consumed blocks at a time. Finally, fire codes demanded that steel frames and fireproofing materials be used in all new construction of hotels. The only things that destroyed the newer hotels were bulldozers.

Postcards were given out by hotels to their guests and sent as reminders by the management. The downtown shopping district followed suit, as retailers sent out sales notices on postcards to their regular customers. Vendors on the boardwalk and in the variety stores downtown sold postcards of every building and big event in Asbury Park's history.

Today, postcards are not created on as large a scale as they once were but have become collectibles, sold at flea markets and postcard shows. The postcards in this book tell the reader all about the history of Asbury Park and help others to bring back mostly good memories of a beautiful city by the great Atlantic Ocean.

About the Author
Shirley Ayres, a professional librarian, is the appointed historian for Bradley Beach, a member the executive board of the Bradley Beach Historical Society, a writer of historical articles for the local newspapers, and the coauthor of Arcadia's Images of America book on Bradley Beach and Postcard History Series book about Bradley Beach. For *Asbury Park*, the author selected postcards from the excellent collection of the Asbury Park Public Library

One

The Hotels,
Grand and Otherwise

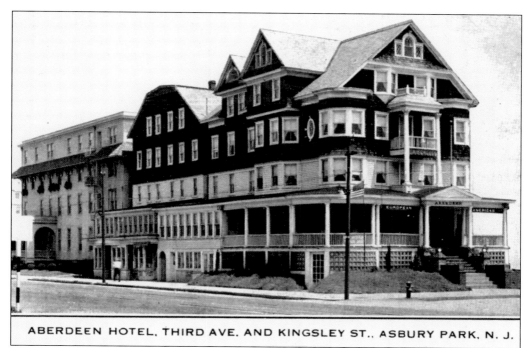

ABERDEEN HOTEL, THIRD AVE. AND KINGSLEY ST., ASBURY PARK, N. J.

ABERDEEN HOTEL. The Aberdeen Hotel was located at the corner of Third Avenue and Kingsley Street, and in 1908, Mrs. M. E. Babcock was the proprietor. It offered American and European plans. In the early 1960s, A. S. Wittlin was the proprietor, and P. L. Wyman was the manager. The telephone number was Asbury Park 2-1681.

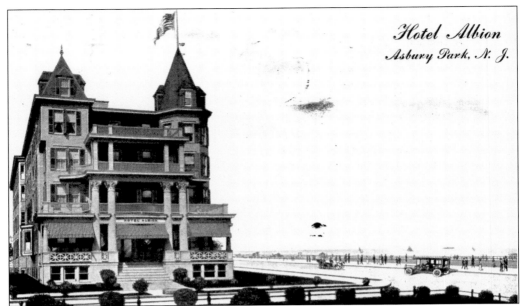

HOTEL ALBION. The Hotel Albion stood on the corner of Second and Ocean Avenues. This card was postmarked on August 23, 1915.

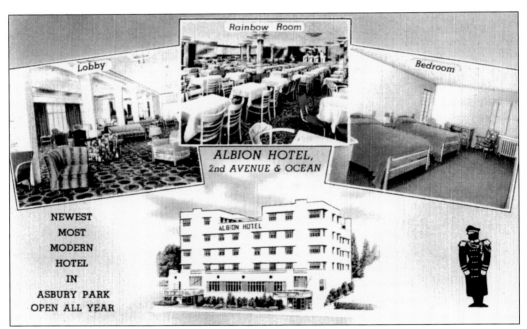

ALBION HOTEL. The modern version of the original Albion Hotel featured a large Floridian swimming pool on the Ocean Avenue side of the hotel. The hotel's postcard boasted, "Finished in 1942 with all modernistic furnishings. Rainbow Room Night Club featuring dancing every night. Overlooking the ocean. 100% fireproof hotel and motel. Private terrace. Free Parking. Individually controlled AC, heating, TV & HiFi. Ocean bathing. Prospect 6-8300. In New York Digby 9-1195."

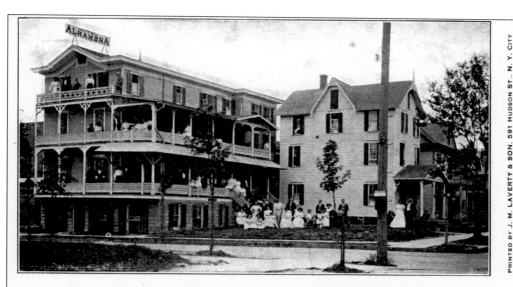

HOTEL ALHAMBRA and ANNEX, 400 Sewall Avenue, cor Heck Street, Asbury Park, N. J.
Electric cars from Depot or Boat pass in sight of hotel at Cookman Avenue and Heck Street. Centrally located overlooking Ocean, and Wesley Lake. Within two blocks of the Beach and Casino. Terms moderate.
Telephone, 1310-W Asbury Park. GILL-KIMBLE, Owner and Proprietor.

HOTEL ALHAMBRA AND ANNEX. The Alhambra was located at 400 Sewell Avenue, on the corner of Heck Street. Centrally located, it overlooked the ocean and Wesley Lake and was within two blocks of the beach and the Casino. Its terms were moderate, and its telephone number was 1310-W Asbury Park. Gill Kimble was the owner and proprietor. This postcard dates from *c.* 1900.

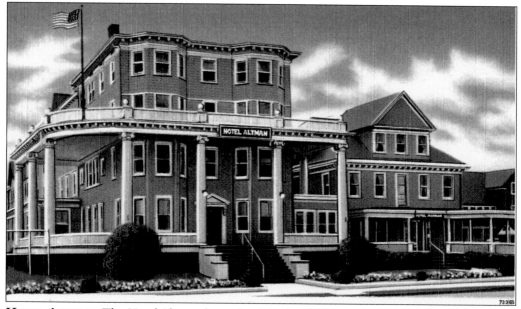

HOTEL ALTMAN. The Hotel Altman, located at 210 Eighth Avenue, was owned by Weiss Inc. The postcard, which is from the early 1970s, mentions the hotel's free bathing, dietary laws, counselor-supervised kiddieland, and location—one block from the beach. The telephone number was Prospect 5-0004.

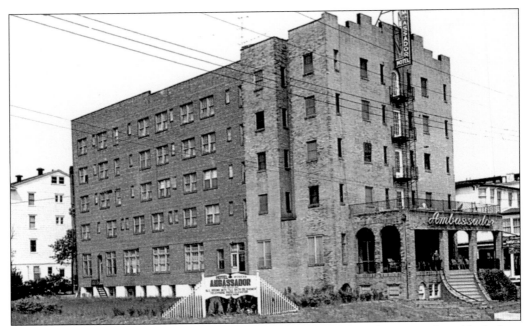

AMBASSADOR HOTEL. Located at 217 Third Avenue, the Ambassador was a short block from the beach and boardwalk. It had a dining room, a cocktail lounge, elevator service to the street entrance, and free parking. Each room had a bathtub, shower, telephone, and radio. Hot saltwater baths were available, and all guests had access to the celebrated Monte Carlo pool. The hotel was open year-round and offered catering service for banquets and conventions. The telephone number was Prospect 5-3234.

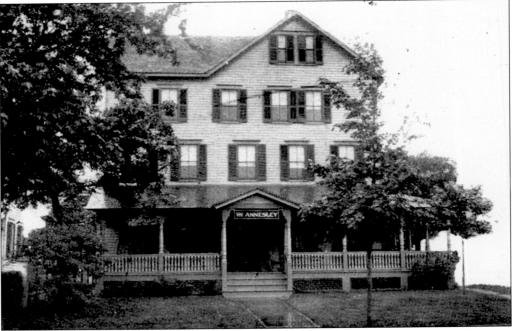

THE ANNESLEY. This pre–World War I postcard shows the original Annesley, at 512 First Avenue.

OPEN ALL YEAR PHONE 2753

THE ANNESLEY

TODD & HALL

512 FIRST AVENUE

NEAR GRAND AVENUE

ASBURY PARK. N. J.

ROOMS

WITH AND WITHOUT

PRIVATE BATH

CAPACITY 75

THE ANNESLEY. This postcard, dated April 26, 1942, shows the renovated edition of the hotel at 512 First Avenue, near Grand Avenue. Owned by Todd & Hall, the hotel had a capacity for 75 guests and was open all year. It offered rooms with hot and cold running water, and with or without a private bath. Described as a "select family house," the hotel offered room rates from $4 per day and up. The telephone number was 2753.

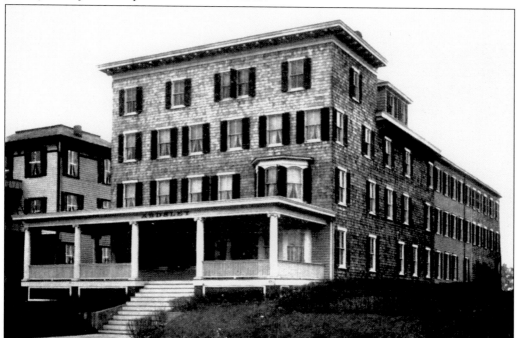

HOTEL ARDSLEY. The Hotel Ardsley, located at 214 Second Avenue, was destroyed by the great fire of April 15, 1917. Firefighters deliberately dynamited the hotel to make a firebreak, but the fire jumped over the hotel and kept going. This card was postmarked on August 6, 1912.

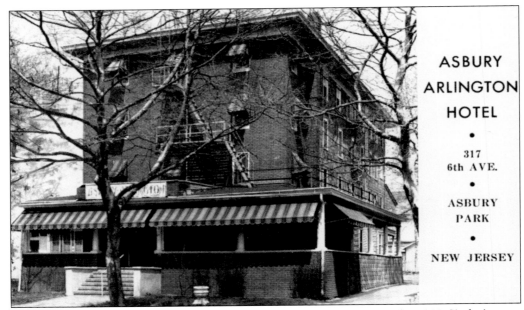

ASBURY ARLINGTON HOTEL. The Asbury Arlington Hotel was located at 317 Sixth Avenue. Paul Kondia was the owner and manager. The hotel offered American and European plans and rooms with or without a bath. The telephone numbers were Prospect 4-9731 and 5-1839.

UNTITLED. Asbury Aurora's postcard states: "For an interesting vacation and wholesome relaxation, the Asbury Aurora is a perfect summer rendezvous. Only one block to ocean and boardwalk. 60 comfortable and cheerful rooms, all with running water. Homey atmosphere. Complimentary breakfast. Rates: Double room, two persons $35 weekly; Single room, one person $17–$19 weekly; Daily, per person $2.50 up; Double room, private bath $50–$60 weekly. Josephine Fariello, owner-manager. Member Chamber of Commerce."

UNTITLED. Asbury Hollywood Hotel was located at 220 Fourth Avenue. These postcards were sent to customers from previous years to remind them to book rooms at the four-story hotel. The message reads: "Ideally located one block from the ocean. For your comfort and enjoyment, patio porches, sun deck, television, free parking for guests, coffee shop. Mr. and Mrs. Fred Erichsen, Owner-management. . . . All rooms without bath have hot and cold running water. Special monthly and seasonal rates."

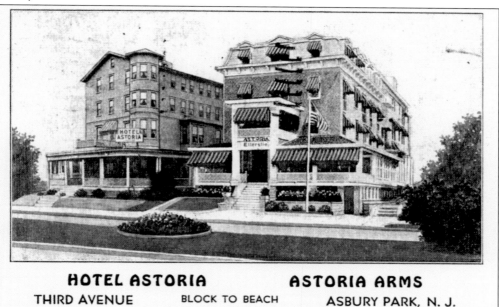

HOTEL ASTORIA ASTORIA ARMS
THIRD AVENUE BLOCK TO BEACH ASBURY PARK, N. J.

HOTEL ASTORIA AND ASTORIA ARMS. Raymond E. Wagner owned and operated both the Astoria and the larger Astoria Arms, on Third Avenue, a block away from the beach. The message on this card reads: "Single rooms from $1.50 daily. Room with bath: single $3. to $3.50 Summer. $18–$21. European plan weekly. Double room with bath $4 to 4.50 Summer. $22 to $28 European plan weekly." The card was postmarked on September 24, 1938.

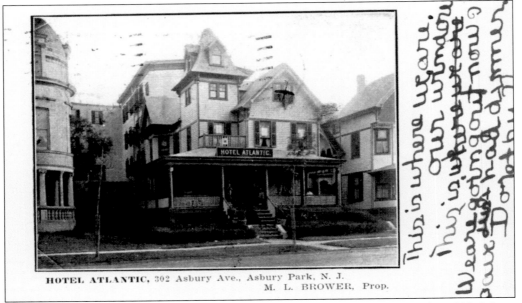

HOTEL ATLANTIC, 302 Asbury Ave., Asbury Park, N. J.
M. L. BROWER, Prop.

HOTEL ATLANTIC. M. L. Brower was the proprietor of the Atlantic, located at 302 Asbury Avenue. This card was postmarked on August 2, 1908.

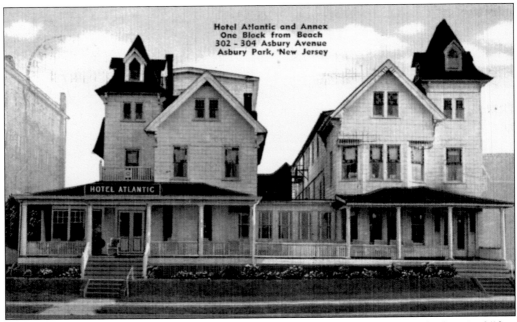

Hotel Atlantic and Annex
One Block from Beach
302 - 304 Asbury Avenue
Asbury Park, New Jersey

HOTEL ATLANTIC

HOTEL ATLANTIC AND ANNEX. Located at 302–304 Asbury Avenue, the hotel advertised "free ocean bathing" and was "one block to beach . . . near restaurants and theatres." It offered the European plan, as well as television, "reasonable rates," and a "home-like atmosphere." Its season ran from May 1 to October 15. "For reservations phone PR4-9899. Ask for Mr. and Mrs. J. E. Willett." This card was postmarked on July 10, 1949.

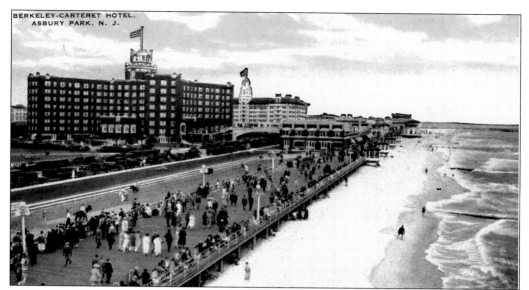

BERKELEY CARTERET HOTEL. Standing at 1415 Ocean Avenue at Sunset Avenue, the Berkeley Carteret featured top Broadway entertainment and dancing. It had 400 "modern rooms and baths" and "four smart restaurants." The hotel opened for business on July 1, 1925, with Arthur C. Steinbach as president, S. Heilner Calvert as vice president, William A. Berry as secretary-treasurer, and five other members of the board of directors—Dr. James A. Fisher, Dr. James F. Ackerman, Howard Huleck, Harry Ingolis, and D. Frederick Burnett.

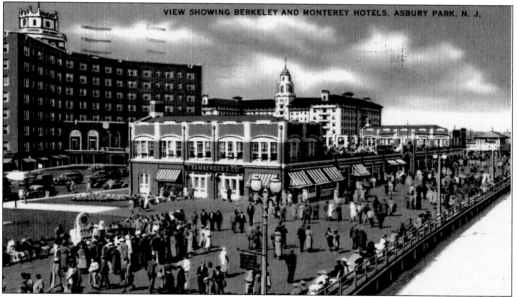

VIEW SHOWING BERKELEY AND MONTEREY HOTELS. All rooms had outside exposure. The hotel featured 420 rooms with bath, shower, and running fresh water and salt water. Suites filled the upper floors, and upscale shops and professional offices occupied the first-floor rooms of each of the four wings. During the off-season, from October 1 to April 30, the hotel rented 100 apartment units and maintained one dining room for the tenants. A bridge from the hotel's second floor to the arcade on the boardwalk allowed guests to go to the beach without having to leave the hotel property.

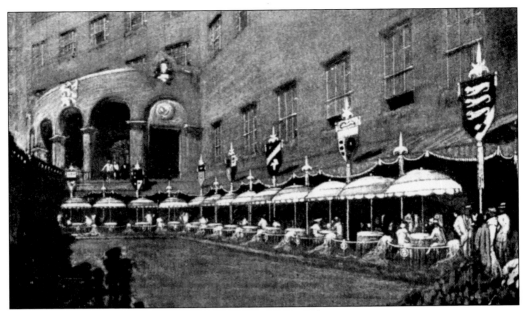

UNTITLED. Shown is the Berkeley Carteret Hotel's Berkeley Terrace.

UNTITLED. The drawing room of the Berkeley Carteret Hotel is pictured in this view.

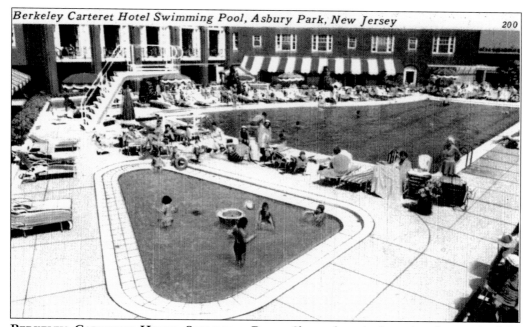

BERKELEY CARTERET HOTEL SWIMMING POOL. Shown here is the swimming pool of the Berkeley Carteret Hotel.

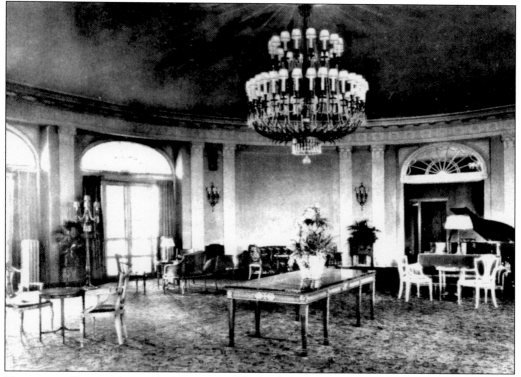

UNTITLED. Pictured is the Oval Lounge of the Berkeley Carteret Hotel.

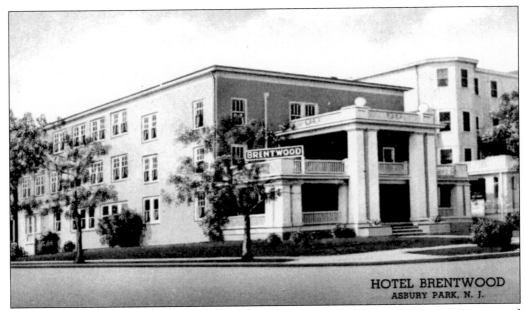

HOTEL BRENTWOOD
ASBURY PARK, N. J.

HOTEL BRENTWOOD. The Hotel Brentwood was located at the corner of First Avenue and Bergh Street. The hotel "enjoys a delightful corner location, one short block from the beachfront. Comfortable attractive rooms. Close to churches, theatres and shopping center. Just around the corner from all boardwalk attractions, yet sufficiently removed to insure the relaxation so necessary for a real vacation. Attractive rates." R. H. Hoff was the proprietor.

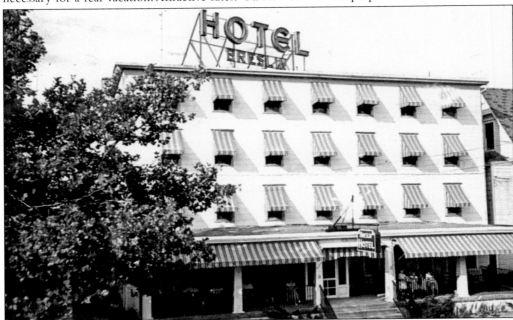

UNTITLED. Hotel Breslin, at 315 Sewell Avenue, was "ideally located two blocks from ocean." It advertised "porches and television for your comfort and enjoyment. July and August rates: Daily, single $3.00, double $5.00 to $6.00 and up. . . . All rooms with hot and cold running water. Special monthly and seasonal rates."

HOTEL BRIGHTON. Located at 211 Third Avenue, the hotel was open all year, and Mrs. W. G. Morton, a former owner of the Poughkeepsie Hotel, was the proprietor. This card was postmarked August 1, 1941.

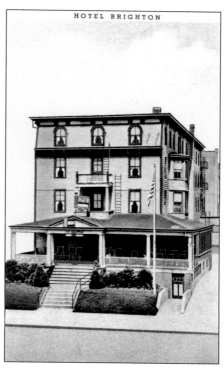

HOTEL BRIGHTON

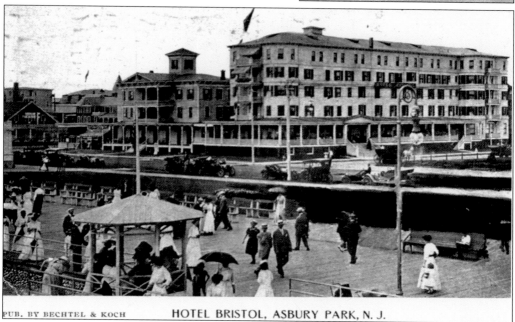

PUB. BY BECHTEL & KOCH HOTEL BRISTOL, ASBURY PARK, N. J.

HOTEL BRISTOL. The Hotel Bristol, built in the gingerbread style, was erected on the southwest corner of Ocean and Fourth Avenues in 1878. The porches were later removed, the building was lengthened, and a fifth floor was added. On October 6, 1923, the hotel was destroyed by a fire that leveled the greater part of the block bounded by the ocean, Third and Fourth Avenues, and Kingsley Street. This card was postmarked on February 8, 1917.

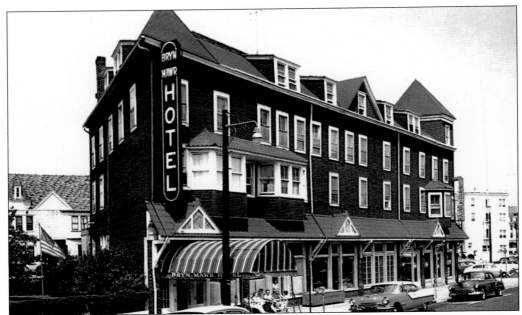

UNTITLED. Open year-round, the Bryn Mawr Hotel had a coffee shop and stood at 311 Cookman Avenue. It offered all "outside" rooms, each with a television set and a private bath with shower. It also offered apartments with kitchen facilities. Rates started at $8 per night.

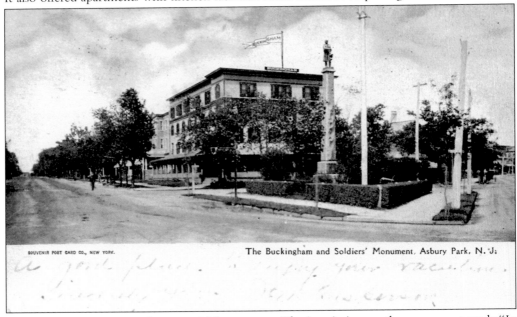

The Buckingham and Soldiers' Monument, Asbury Park, N. J.

THE BUCKINGHAM AND SOLDIERS' MONUMENT. The inscription on the monument reads: "In honor of those who fought in defense of the Union, 1861–1865. Erected by C. K. Hall Post #41, C.A.R. Dept. of N.J. and Women's Relief Corps #25." The statue was brought by founder James Adam Bradley to the foot of Asbury Avenue and placed on a small pedestal. It was later moved to the park in the triangle of Cookman and Grand Avenues, where it stands today. The Hotel Buckingham is behind the park. This card bears a postmark of June 26, 1909.

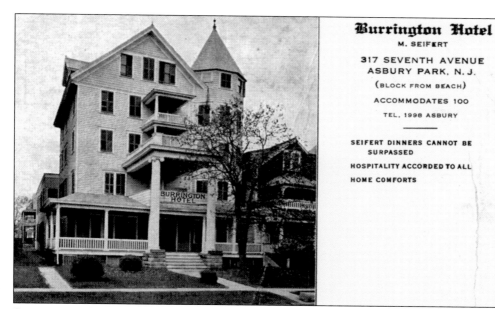

BURRINGTON HOTEL. The Burrington Hotel, with M. Seifert, as proprietor, stood at 317 Seventh Avenue, one block from the beach. The hotel advertised that "Seifert dinners cannot be surpassed. Hospitality accorded to all. Home comforts."

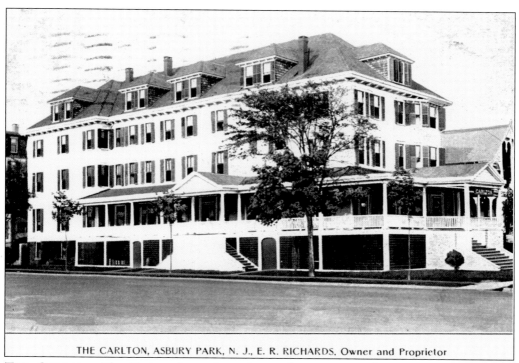

THE CARLTON, ASBURY PARK, N. J., E. R. RICHARDS, Owner and Proprietor

THE CARLTON. The Carlton, located on the northeast corner of First Avenue and Bergh Street, was operated by Ella Richards Havercamp from 1885 until it was destroyed by fire on August 14, 1915. This card was postmarked on September 2, 1913.

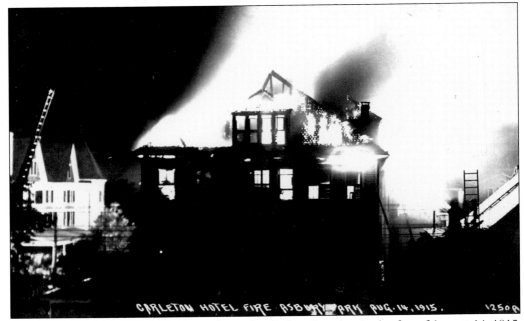

CARLETON HOTEL FIRE. This view shows the Carlton burning in the fire of August 14, 1915. The hotel was rebuilt in 1916 but was destroyed again in the great fire of April 15, 1917, which demolished four city blocks of hotels and residences.

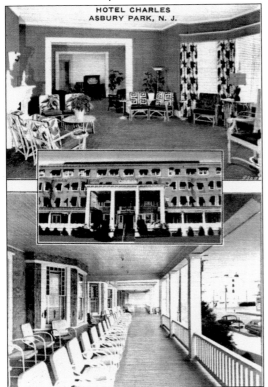

HOTEL CHARLES. This card, postmarked on May 21, 1953, shows three views—the lobby, the porch, and the exterior of the Hotel Charles. Located at 209 Asbury Avenue, "close to all activities," the four-story hotel had 110 rooms and a 125-foot-long porch with an ocean view. Charles Braverman was the owner and manager.

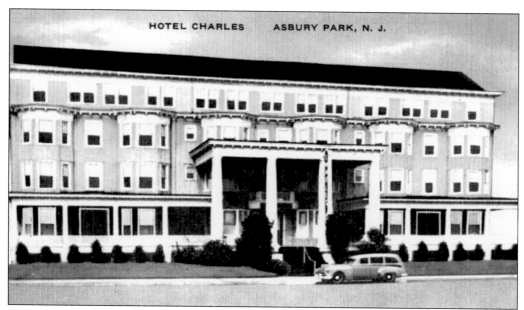

HOTEL CHARLES. Postmarked on May 21, 1953, this card shows the front of the hotel and states, "You'll be glad you selected." The hotel was located at 209 Asbury Avenue.

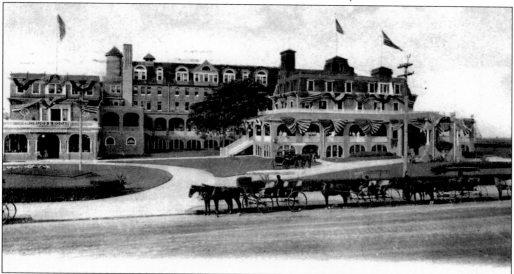

UNTITLED. The Coleman House was built on Asbury Avenue, at the corner of Ocean Avenue, in 1874 by John Sherman Cook for owner Sarah Coleman. Operated by J. S. Ripley, the hotel opened on July 1, 1879. In 1880, Ripley built the extension along Asbury Avenue, and in 1888, he added a four-story brick addition. Later, former mayor Frank L. Ten Broeck assumed management of the hotel. In 1902, Ten Broeck's son-in-law added bowling alleys and a dance hall. The hotel played host to Sir Thomas Lipton, Mary Pickford, Alice Brady, Maude Adams, Gentleman Jim Corbett, and U.S. presidents Ulysses S. Grant, Woodrow Wilson, and Herbert Hoover. In 1882, Oscar Wilde, Irish poet and playwright, visited Monmouth County on a lecture tour. In 1911, Sarah Coleman sold her hotel and retired from the business. After diminishing income doomed it, the hotel was torn down in 1934 to make room for a parking lot.

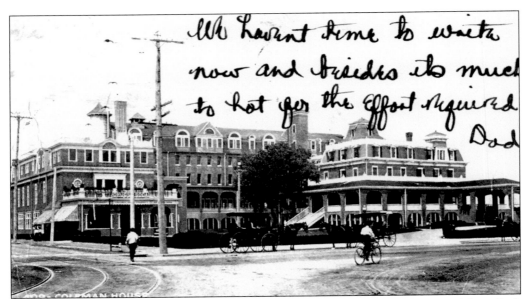

We haven't time to waste now and besides its much to hot for the effort required. Dad

UNTITLED. On October 24, 1924, the 35-man Notre Dame football team came to Asbury Park before the Princeton game. The team went to the Coleman House for lunch and then worked out at the Deal Country Club's polo field while 150 fans watched coach Knute Rockne put the Princeton opponents through their paces. Later, Notre Dame beat Princeton. This card was postmarked on July 17, 1911.

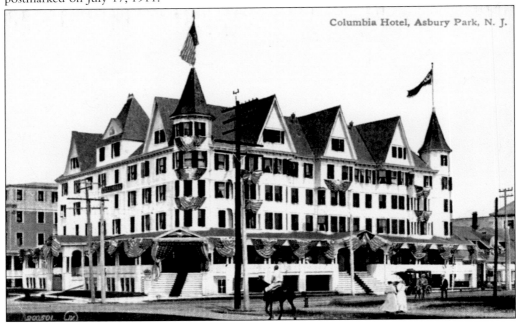

Columbia Hotel, Asbury Park, N. J.

COLUMBIA HOTEL. The Columbia was located at 201 Sixth Avenue, at the corner of Kingsley Street. It had three entrances—one on Kingsley Street, one on Sixth Avenue, and one on an angle between them. With accommodations for 300 guests, it offered elevator service, a cocktail lounge, European-plan dining, and the largest veranda on the New Jersey coast. W. Harvey Jones was the proprietor.

THE DOTHAN. Overlooking Sunset Lake, the Dothan stood at 514 Fifth Avenue, at the corner of Emory Street. It was on the trolley line and was convenient to the beach and all amusements. Open from May to October, it offered "comfortable entertainment" for 35 guests. Joseph E. Potter was the proprietor.

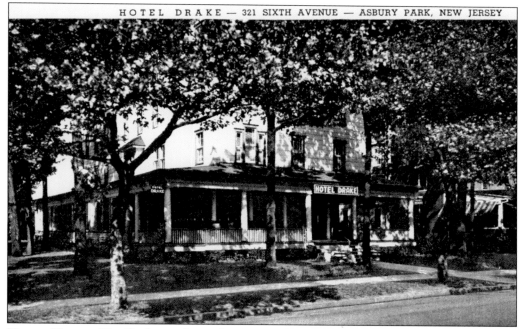

HOTEL DRAKE — 321 SIXTH AVENUE — ASBURY PARK, NEW JERSEY

HOTEL DRAKE. The Drake was located at 321 Sixth Avenue, "Where Strangers Meet and Part as Friends." It offered American and European plans, all outside rooms with running water, and some rooms with private or semiprivate baths—all at "reasonable rates." It boasted a "spacious, tree-shaded, restful porch" and a "roomy lobby with TF, library, and recreation room." This card was postmarked on July 9, 1955.

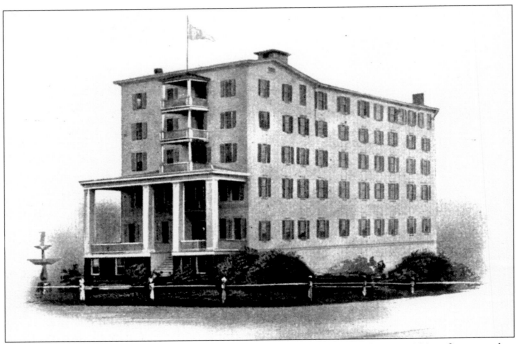

UNTITLED. The Hotel Edgemere stood on Fourth Avenue. On October 6, 1923, a fire started at 9:00 p.m. in the Garden Theatre, on Ocean Avenue between Third and Fourth Avenues. The fire destroyed not only the Edgemere but also the Bristol, Keswick, and Victoria Hotels, as well as Hall Cottage and the Ocean Cafeteria and Apartments. This card bears a postmark of June 15, 1909.

UNTITLED. Directly on the oceanfront, the Empress Motel featured 101 modern rooms that overlooked either the ocean or the pool. Each room had a telephone, a television set, a picture window, and a patio. Open year-round, the motel was fully air-conditioned and offered 24-hour elevator service, a dining room, a cocktail lounge, indoor and outdoor heated swimming pools, surf bathing, and free parking on premises. This card is postmarked September 5, 1967.

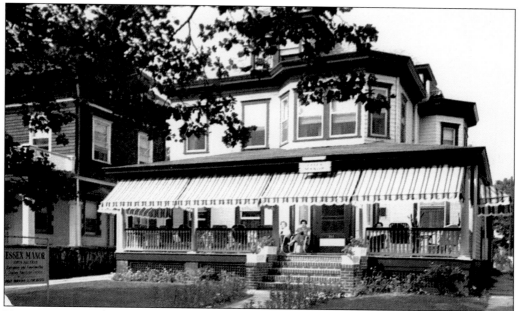

UNTITLED. Essex Manor, at 311 Sixth Avenue, was located one and a half blocks from the beach and pool. All rooms had hot and cold running water. Two-room apartments, with private bath and showers, were also available. European and American food was served in "a refined family atmosphere," and free parking was available. Essex Manor was open year-round. Anthony M. Grieco was the proprietor.

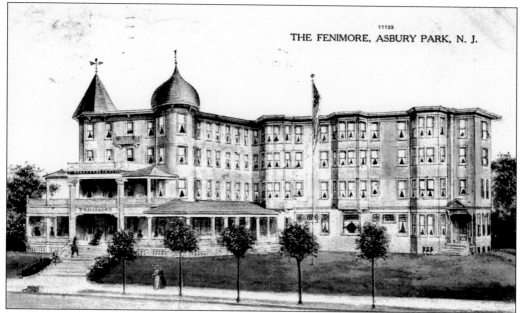

THE FENIMORE. Located at 213 Second Avenue, the hotel featured a complimentary light breakfast on the European plan. Thomas Noble was the proprietor. The original design showed two small peaked roofs and a second-floor balcony on this sprawling four-story hotel. The postmark of this card is September 2, 1912.

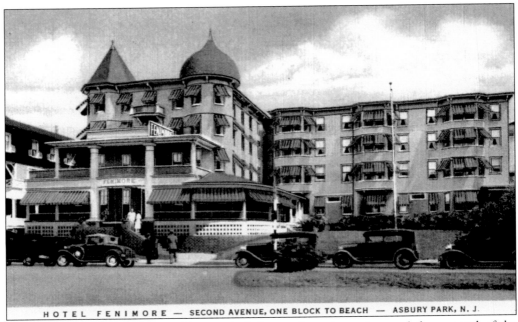

HOTEL FENIMORE — SECOND AVENUE, ONE BLOCK TO BEACH — ASBURY PARK, N. J.

HOTEL FENIMORE. With the addition of window and porch awnings and the removal of the peaked roofs on the second-floor balcony, the Fenimore appears to be the same as when it first opened. This card was postmarked on August 13, 1937.

UNTITLED. Flamingo Motel was located at the corner of First Avenue and Kingsley Street, facing the ocean and boardwalk. It was open all year and was advertised as being fireproof. The hotel offered air-conditioned rooms, and efficiency units were available. Free bathing, television, and parking were selling points.

HOTEL FRANKLIN. Also called the Benjamin Franklin Inn, the hotel was located at 208 Sixth Avenue, at the corner of Webb Street. Beginning in 1887, the hotel was operated by Catherine and Edward Stroub, the parents of Carrie F. Stroud, who took ownership in 1925. The hotel had 100 outside rooms, each with an ocean view. The hotel and gift shop featured a large collection of historical items pertaining to the life of Benjamin Franklin. This card was postmarked on July 6, 1921.

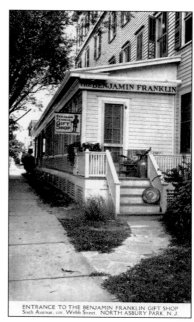

ENTRANCE TO THE BENJAMIN FRANKLIN GIFT SHOP
Sixth Avenue, cor. Webb Street. NORTH ASBURY PARK, N.J.

ENTRANCE TO THE BENJAMIN FRANKLIN GIFT SHOP. The gift shop, with its entrance on Webb Street, featured items that had a Benjamin Franklin accent.

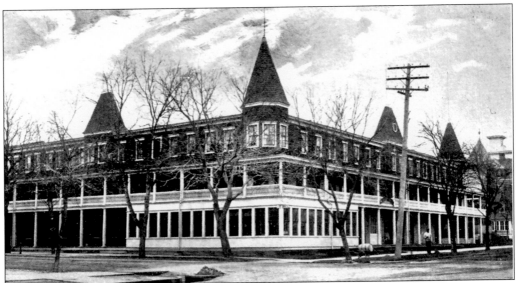

UNTITLED. Operated by Lybrand Sill and J. S. Ripley, the Grand Avenue Hotel was built in 1873 at the northwest corner of Grand and Summerfield, and was razed in 1913. The site was later occupied by the Jersey Central Power and Light Company. On New Year's Eve 1899, the Ariel Club's Yuletide Euchre Dance at the Grand Avenue Hotel was held for 200 guests. A stringed orchestra was hidden behind a screen of palms for the dancing pleasure of the guests. This card was postmarked on September 2, 1911.

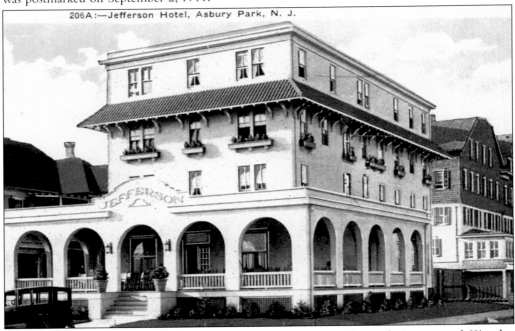

206A:—Jefferson Hotel, Asbury Park, N. J.

JEFFERSON HOTEL. The Jefferson was located at the corner of Fourth Avenue and Kingsley Street. Fred Martell was the owner. The hotel featured 100 rooms and 50 baths and was on the European plan. The building was torn down in the 1980s as part of the beachfront redevelopment plan. The lot is still vacant. The postmark of this card is August 24, 1926.

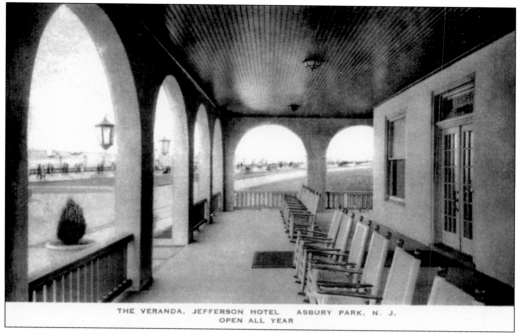

THE VERANDA, JEFFERSON HOTEL ASBURY PARK, N. J.
OPEN ALL YEAR

THE VERANDA, JEFFERSON HOTEL. This postcard features the view from the airy wraparound front porch of the Jefferson Hotel.

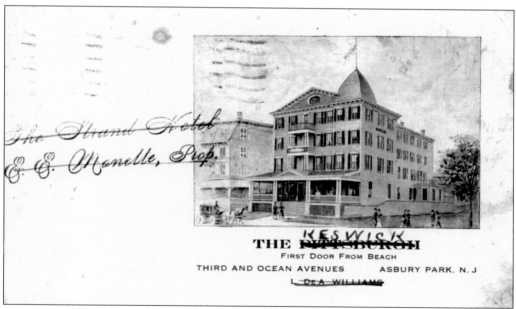

THE KESWICK
THE PITTSBURGH
FIRST DOOR FROM BEACH
THIRD AND OCEAN AVENUES ASBURY PARK, N. J
L. DE A. WILLIAMS

THE KESWICK. The Keswick Hotel was located at 207 Third Avenue. This postcard is unusual because it shows how many name changes the hotel had endured. The new owner of this hotel once known as the Strand Hotel, and later the Pittsburgh, was unable to make new postcards to show the current hotel name, so it had to be written in over the scratched-out former names. The card was postmarked on July 29, 1917.

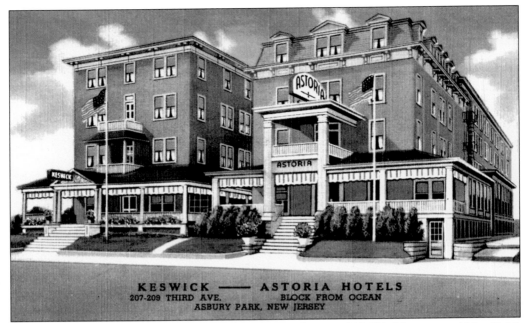

KESWICK —— ASTORIA HOTELS
207-209 THIRD AVE. BLOCK FROM OCEAN
ASBURY PARK, NEW JERSEY

KESWICK—ASTORIA HOTELS. The hotels were located at 207–209 Third Avenue, and Mrs. B. M. Kane and Arthur D. McTighe were the owner-operators. A choice of American and European plans was offered to guests. There was a capacity of 300 guests. All accommodations were outside rooms with running water, many with private bath and shower.

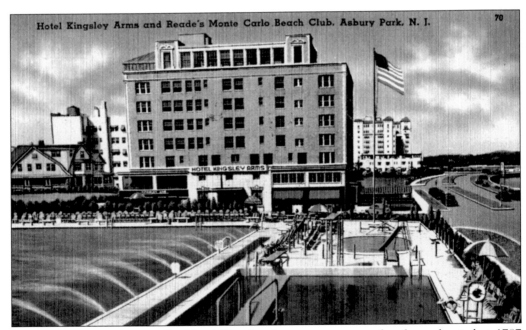

Hotel Kingsley Arms and Reade's Monte Carlo Beach Club, Asbury Park, N. J. 70

HOTEL KINGSLEY ARMS. The Hotel Kingsley Arms, an apartment hotel, was located at 1707 Kingsley Street, on the corner of Deal Lake Drive, overlooking Reade's Monte Carlo Beach Club and pool. Behind the hotel, on the left, is the Santander apartment building.

UNTITLED. The Lafayette Hotel was located at 301 Fourth Avenue. This card shows the original design of the hotel, with an observation deck on the roof. In later postcards, the deck has been replaced by a fifth floor. The back of the postcard reads: "Orchestra and master of ceremonies featured nightly. Six thousand square feet of concrete piazzas, with concrete culinary departments. Large number of corner suites and other rooms with private baths. Fireproof roof. Privilege tub, showers and needle bathrooms on each floor. Running iced water. Bachelor apartments available. Otis electric elevator, barber shop, hotel tailor and valet, hair dresser and manicurist."

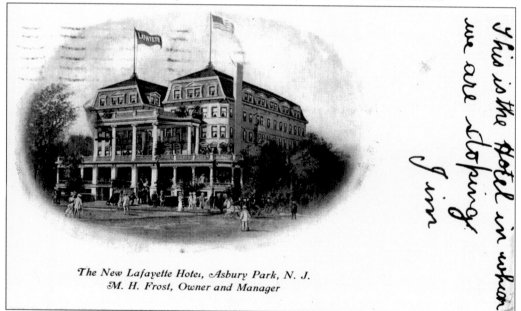

The New Lafayette Hotel, Asbury Park, N. J.
M. H. Frost, Owner and Manager

THE NEW LAFAYETTE HOTEL. This *c.* 1910 promotional postcard, sent to future vacationers, shows the newly added fifth floor. M. H. Frost was the owner and manager who wrote the following unsubtle messages on the card: "White service. Patronage of Hebrews not solicited." Later postcards claim, "Finest Dietary Law Hotel."

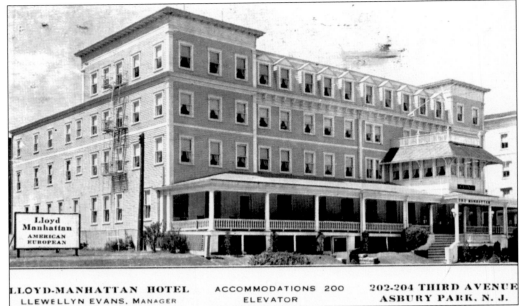

LLOYD-MANHATTAN HOTEL ACCOMMODATIONS 200 202-204 THIRD AVENUE
LLEWELLYN EVANS, MANAGER ELEVATOR ASBURY PARK, N. J.

LLOYD-MANHATTAN HOTEL. The Lloyd-Manhattan Hotel was located at 202–204 Third Avenue, and Llewellyn Evans was the manager. There were accommodations for 200 guests. Elevator service was available. Evans sent his postcard to future vacationers with this typewritten message on the reverse: "Give Asbury Park a 'Big Bit' of consideration when making your vacations plans. Come to our beautiful resort, you'll have no regrets." The postmark is June 30, 1940.

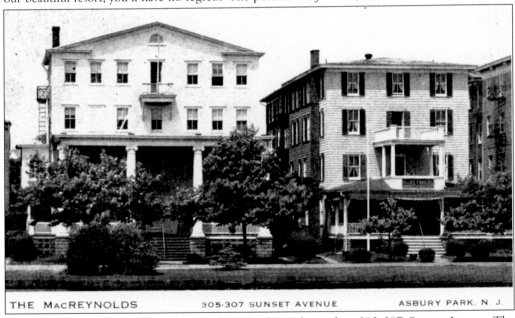

THE MacREYNOLDS 305-307 SUNSET AVENUE ASBURY PARK, N. J.

THE MACREYNOLDS. The MacReynolds Hotel was located at 303-307 Sunset Avenue. The back of the postcard claims: "Delightfully situated two blocks from the beach, overlooking Sunset Lake, near all churches. Capacity 250. Excellent home cooking. Hot and cold running water in all rooms. Some private shower rooms, lavatories, bath rooms."

UNTITLED. The MacReynolds Hotel's porch view is featured on this postcard.

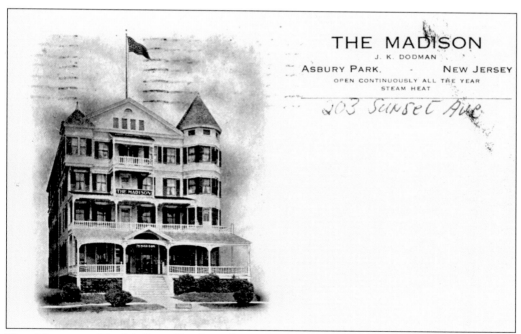

THE MADISON

J. K. DODMAN

ASBURY PARK. - NEW JERSEY

OPEN CONTINUOUSLY ALL THE YEAR
STEAM HEAT

203 Sunset Ave

THE MADISON. The Madison Hotel was located at 203 Sunset Avenue. This is the older of the two hotels named the Madison. The four-story building featured small third- and fourth-floor porches, a larger second-floor porch, as well as the main-floor porch spanning the front of the building. This card was postmarked on March 13, 1912.

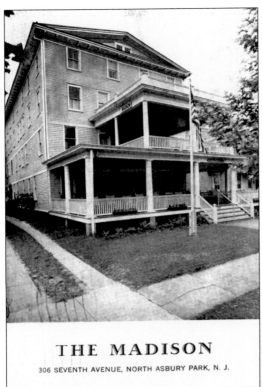

THE MADISON

306 SEVENTH AVENUE, NORTH ASBURY PARK, N. J.

THE MADISON. This Madison Hotel was located at 306 Seventh Avenue, North Asbury Park. Located in the third block from the ocean on Seventh Avenue, this hotel was about two blocks north of the Sunset Avenue Madison Hotel. The postmark of this card is July 14, 1948.

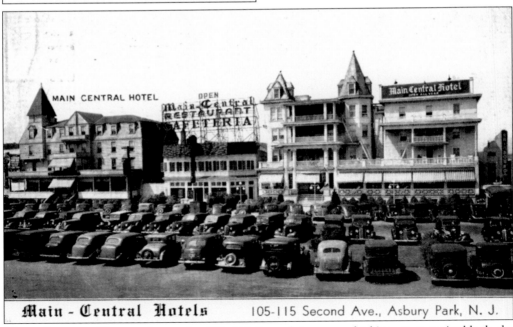

Main - Central Hotels 105-115 Second Ave., Asbury Park, N. J.

MAIN-CENTRAL HOTELS. Located at 105–115 Second Avenue and taking up an entire block, the Main-Central complex featured a cafeteria as well as two grand hotels. The back of the postcard reads: "Rainbow Room night club adjoining. American and European plans. Open all year."

MARGUERITE. The Marguerite Hotel was located at 508 Third Avenue, and M. L. Williamson was the manager. It was open all year. The postmark of this card is March 22, 1935.

MARGUERITE

508 Third Avenue

Asbury Park, New Jersey

M. L. WILLIAMSON, Manager

Conveniently located near Ocean

OPEN ALL YEAR

Telephone Asbury Park 4518

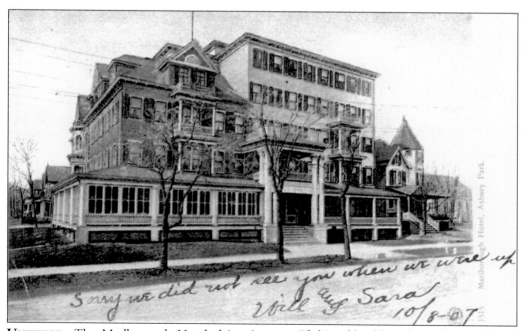

UNTITLED. The Marlborough Hotel claims it was a "fashionable although modest residential hotel at the corner of Grand and Monroe Avenues." The postmark is October 9, 1907.

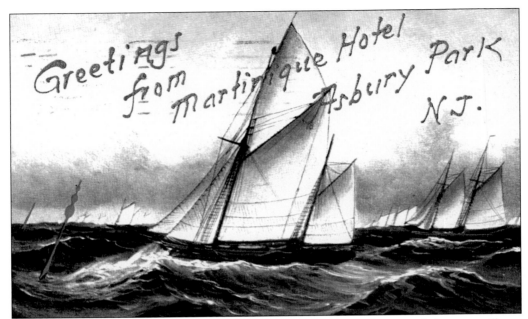

GREETINGS FROM MARTINIQUE HOTEL. The Martinique Hotel postcard features sailboats instead of a picture of the hotel. Owner E. B. Driggs and manager S. B. Driggs sent this card to future vacationers with the message "Opens for the season Thursday, May 25." The postmark is May 18, 1918.

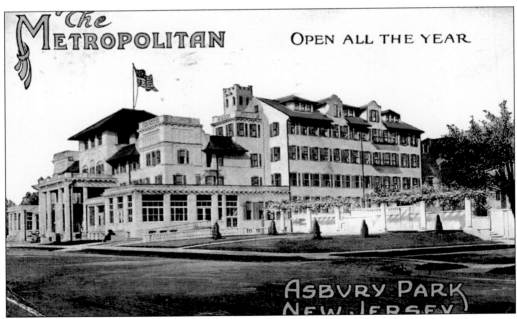

THE METROPOLITAN. The Metropolitan Hotel, located at 301–315 Asbury Avenue, at the corner of Heck Street, opened for business in 1912. The proprietor was S. T. Champion. This card bears a postmark of August 5, 1914.

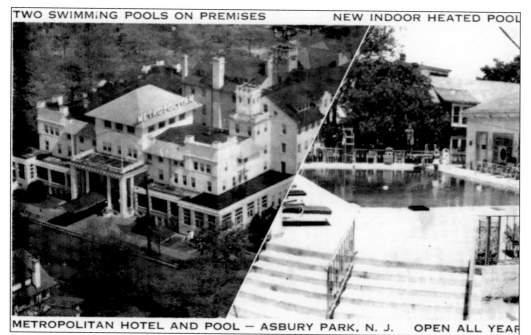

TWO SWIMMiNG POOLS ON PREMISES NEW INDOOR HEATED POOL

METROPOLITAN HOTEL AND POOL — ASBURY PARK, N. J. OPEN ALL YEAR

Metropolitan Hotel and Pool. This two-shot postcard shows an aerial view of the Metropolitan Hotel and its outdoor pool. The hotel also featured an indoor heated swimming pool. The back of the postcard claims: "The largest dietary law hotel in Asbury Park. All rooms are heated and are air conditioned, with two elevators, TV, dining room for 500, entertainment nightly, spacious sun decks and porches, surrounded by parks. Running ice water in every room. Fabulous caterers. Cocktail Lounge on premises."

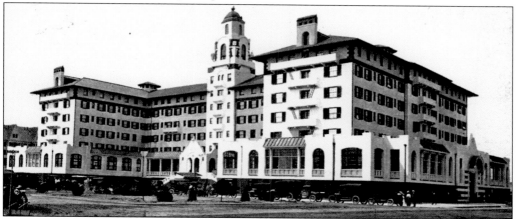

Untitled. Named for the owner's home town of Monterey, California, the Monterey Hotel opened for business in June 1912. Open from May 1 to October 1, the hotel was seven stories tall with 364 hotel rooms. There was a ballroom with tall white pillars that formed a central aisle. The dining room on Kingsley Street could seat 500 people. The hotel was a favorite of opera star tenor Enrico Caruso, who brought his own chef and required a grand piano in his suite. Other guests included Al Smith, the Prince of Wales, and Winston Churchill. In June 1925, the hotel opened for year-round guests. Bankruptcy in the 1950s and 1960s forced the hotel to close. In 1963, the building was condemned and demolished. The lot is still vacant.

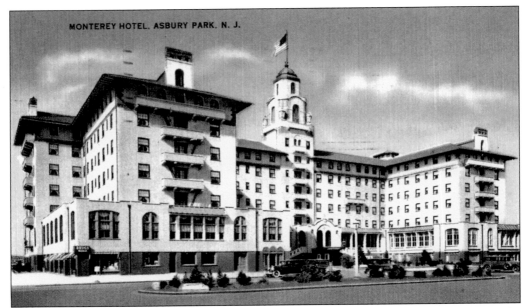

MONTEREY HOTEL. ASBURY PARK, N. J.

MONTEREY HOTEL. During World War II, an eight-foot-high fence was built around the Monterey and Berkeley Carteret Hotels to house about 75,000 English sailors waiting for their new ships to be built. The hotel complex was renamed the HMS *Asbury* by an official Naval Department memo dated September 8, 1942, so that the seamen could receive on-duty pay. Later, the complex became the home of the U.S. Navy training schools for 70 officers and 3,000 young men who completed V-12 training and were awaiting assignment to officer's candidate schools. Sailors were welcomed at the USO (now St. George's Greek Orthodox Church), on Grand Avenue. Officers were wined and dined at "the ship."

UNTITLED. The New Monmouth Sunset Hotel, at 309 Sunset Avenue, was located two blocks from the boardwalk and Convention Hall, and faced Sunset Lake and Sunset Park.

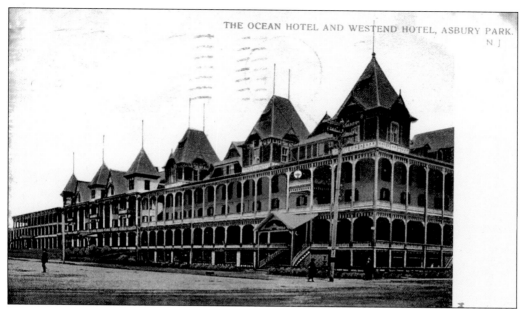

THE OCEAN HOTEL AND WEST END HOTEL. The Ocean Hotel, at 215 Asbury Avenue, is connected to the West End Hotel, which is located at the corner of Asbury Avenue and Kingsley Street. The Ocean Hotel is in the background and includes the three turrets with single flagpoles on each. The West End Hotel has the larger turrets with double flagpoles. Other than the turrets, the hotels are similar. The postmark of this card is July 16, 1908.

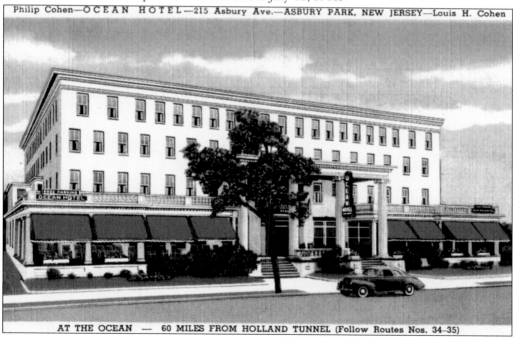

Philip Cohen—O C E A N H O T E L—215 Asbury Ave.—ASBURY PARK, NEW JERSEY—Louis H. Cohen

AT THE OCEAN — 60 MILES FROM HOLLAND TUNNEL (Follow Routes Nos. 34–35)

OCEAN HOTEL. The newer version of the Ocean Hotel is more modern looking, without all the porches and turrets on the roof. The hotel offered an elevator, showers in all rooms, an outdoor theater, and a sun patio.

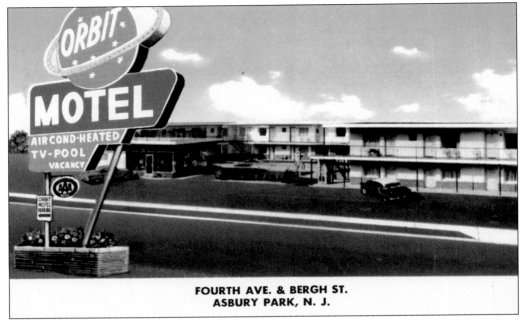

**FOURTH AVE. & BERGH ST.
ASBURY PARK, N. J.**

ORBIT MOTEL. Located at the corner of Fourth Avenue and Bergh Street, the Orbit Motel featured "no-draft" air conditioning and a television in every room. The motel had a private pool for its guests. The back of the postcard claims, "Open all year with special winter rates."

UNTITLED. The Orbit Motel changed hands and became the Orbit Charline Motel. This postcard shows the new motel and a view of the pool. Charles Clayton was the owner.

UNTITLED. Paula's, "the guest house of distinction," was located at 301 Seventh Avenue. It offered spacious rooms, suites, and furnished apartments. Located two blocks from the Monte Carlo pool, the beach, and Convention Hall, Paula's was open all year.

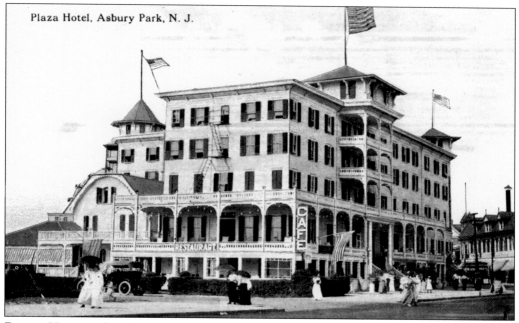

Plaza Hotel, Asbury Park, N. J.

PLAZA HOTEL. The Plaza Hotel and Café, pictured around 1900, was located at 110 Asbury Avenue, on the corner of Kingsley Street, across from Wesley Lake. H. J. and S. A. Bly were the proprietors. The hotel was originally named the Oriental.

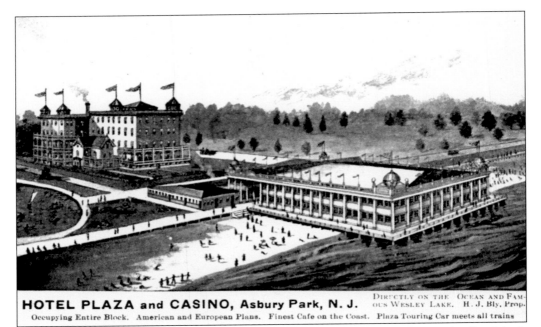

HOTEL PLAZA and CASINO, Asbury Park, N. J. DIRECTLY ON THE OCEAN AND FAM-OUS WESLEY LAKE. H. J. Bly, Prop.

Occupying Entire Block. American and European Plans. Finest Cafe on the Coast. Plaza Touring Car meets all trains

HOTEL PLAZA AND CASINO. The Hotel Plaza occupied the entire block and offered both American and European plans. The Plaza touring car met all trains.

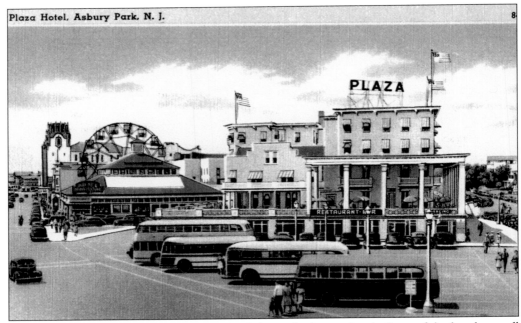

Plaza Hotel, Asbury Park, N. J.

PLAZA HOTEL. This view of the Plaza Hotel shows the bus station in front of the hotel, as well as a double-decker bus. Behind and to the left of the hotel is the Palace amusement center, which included a Ferris wheel. Behind that is the Mayfair Theatre.

27980

PALACE HOTEL. The Palace Hotel, located at 217 Third Avenue, was originally named the Park Roosevelt Hotel. In later years, it became the Ambassador Hotel, which is still standing today.

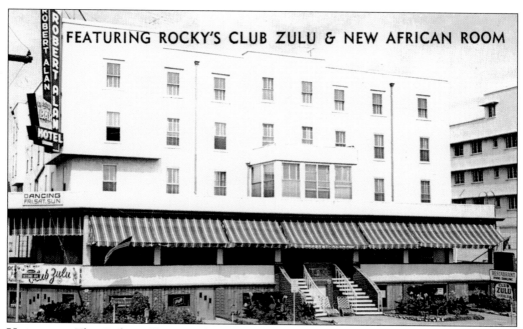

FEATURING ROCKY'S CLUB ZULU & NEW AFRICAN ROOM

UNTITLED. The Robert Alan Hotel was located at 111 Second Avenue, just off the ocean. The back of the postcard claims: "Dancing and entertainment nightly at the fabulous Rocky's Club Zulu and the new African Room. Free ocean bathing. Continental sun deck. Boardwalk amusement gambling games now allowed." R. F. Messina was the owner-manager

47

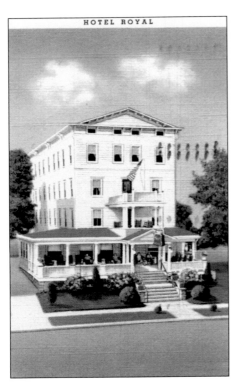

HOTEL ROYAL. The Hotel Royal, located at 216 Third Avenue, had a capacity of 125 guests and offered all outside rooms. The back of the postcard claims, "Hotel newly furnished, noted for its excellent cuisine and home like surroundings." The postmark is August 14, 1940.

THE ST. CLAIRE, 203 Second Ave., Asbury Park, N. J.
MRS. A. J. ROMAIN PATTERSON, Prop.

THE ST. CLAIRE. The St. Claire Hotel was located at 203 Second Avenue, and Mrs. A. J. Romain Patterson was the proprietor. The back of the postcard claims: "One block to beach. Corner hotel with all outside rooms. Capacity one hundred guests."

SEA REST—WHELEN. Located on Heck Street between First and Second Avenues, this hotel was a vacation house of the Young Women's Christian Association of Philadelphia at the beginning of the 20th century. A message on the reverse of this card reads, "Applicants who are not already members of the Y.W.C.A. must pay membership fee of one dollar. This dollar will not be refunded." It was signed by the secretary.

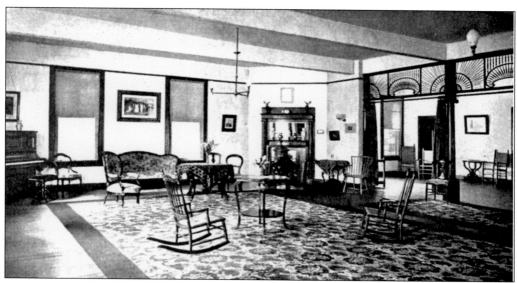

PARLOR. This Sea Rest postcard shows the interior of the hotel and the parlor, where there is a piano and chairs are grouped for socializing.

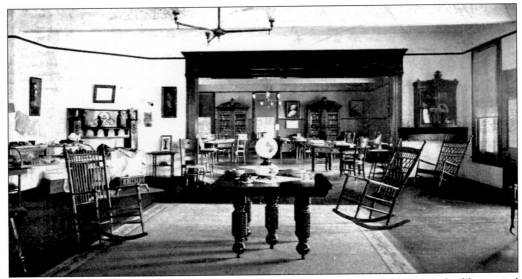

LIBRARY AND RECEPTION ROOM. This card, postmarked August 9, 1909, shows the library and reception room at the Sea Rest.

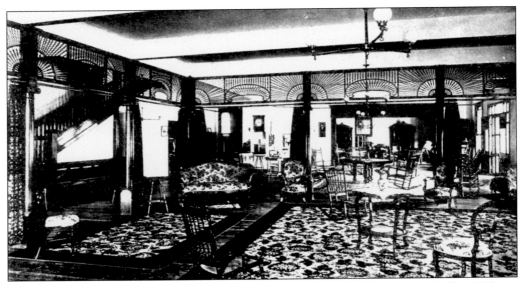

RECEPTION HALL AND LIBRARY. This postcard shows the Sea Rest reception hall and library, the opposite view from the previous card.

OFFICE AND EXCHANGE. The office and exchange (lobby) of the Sea Rest are featured on this card. Gaslights hang from the ceiling in every postcard view of this hotel.

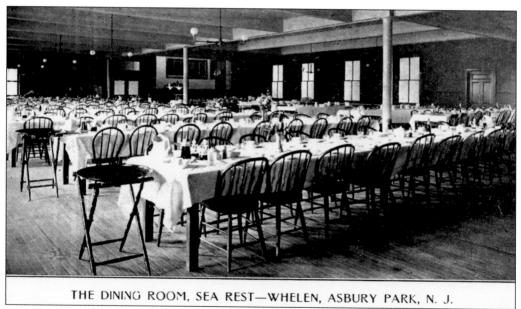

THE DINING ROOM, SEA REST—WHELEN, ASBURY PARK, N. J.

THE DINING ROOM. The dining room at the Sea Rest is set for a meal, dormitory style, where everyone eats at the same time.

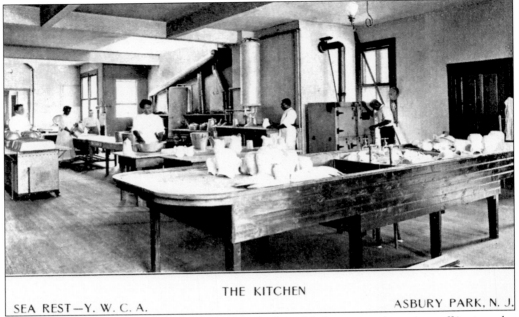

THE KITCHEN

SEA REST—Y. W. C. A. ASBURY PARK, N. J.

THE KITCHEN. This Sea Rest postcard shows the large kitchen area, where the staff is at work.

UNTITLED. The Hotel Shenandoah, at 206 First Avenue, was one block away from the beach, restaurants, and buses, and was convenient to theaters and shopping. Mr. and Mrs. F. Jordan were the owner-managers.

UNTITLED. The Ten Broeck House, located at the corner of Heck Street and Sewall Avenue, was named for the first mayor of Asbury Park, Frank Ten Broeck. The postmark on this card is July 17, 1908.

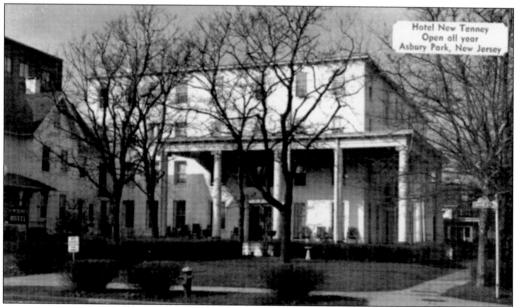

Hotel New Tenney
Open all year
Asbury Park, New Jersey

HOTEL NEW TENNEY. Hotel New Tenney, at 609 Grand Avenue, was the hotel of gracious living and was open all year. The back of the postcard claims: "Centrally located near beaches, theatres and shopping center with clean, airy rooms. Telephone service and running water in all rooms. Rooms with or without bath. Special rates for year-round guests and commercial salesmen."

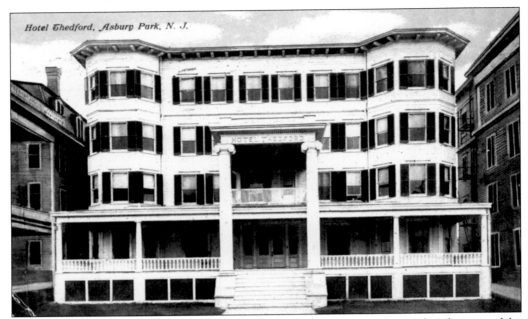

HOTEL THEDFORD. The Hotel Thedford, at 206 Sixth Avenue, was owned and managed by Harry Duffield. The postmark of this card is July 29, 1914.

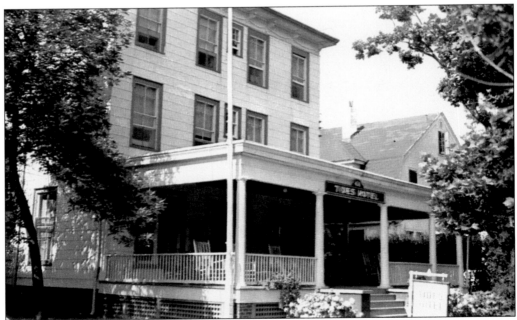

UNTITLED. The Tides Hotel, at 408 Seventh Avenue, was owned and managed by Mr. and Mrs. John Neglia. Their specialty was Italian and American home cooking and a homelike atmosphere. The back of the postcard claims: "All outside rooms with hot and cold water, some with private bath. Reasonable rates by day, week or season."

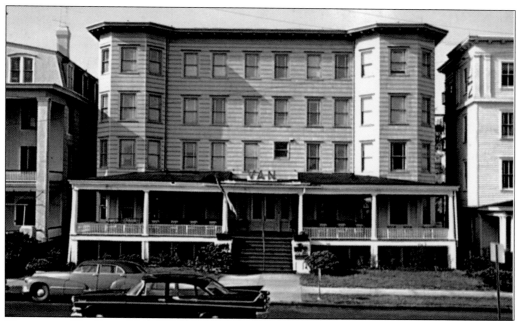

UNTITLED. The Van Hotel, at 206 Sixth Avenue, is the former Hotel Thedford, renamed when Simon Eretzian bought the site. The back of the postcard claims: "Bathing at the Monte Carlo Pool and ocean is free to guests. Armenian Cooking satisfactory to all guests. One hundred cheerful rooms, reservations requested. One block to beach."

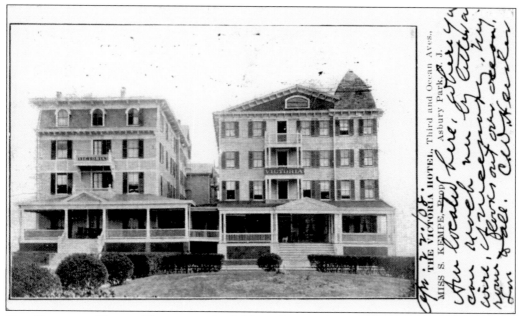

THE VICTORIA HOTEL. The postmark of this card is April 23, 1908, and it is dated April 22, 1908. The Victoria Hotel, located at the corner of Third and Ocean Avenues, was managed by Miss S. Kempe.

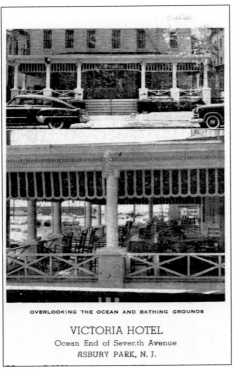

OVERLOOKING THE OCEAN AND BATHING GROUNDS

VICTORIA HOTEL
Ocean End of Seventh Avenue
ASBURY PARK, N. J.

VICTORIA HOTEL. Another hotel named Victoria stood on the Ocean end of Seventh Avenue. This postcard shows the front of the building and a view from the big, shady porch. Owner-manager I. Tuzenew has listed the summer rates on the back of the card, as well as the breakfast and dinner hours.

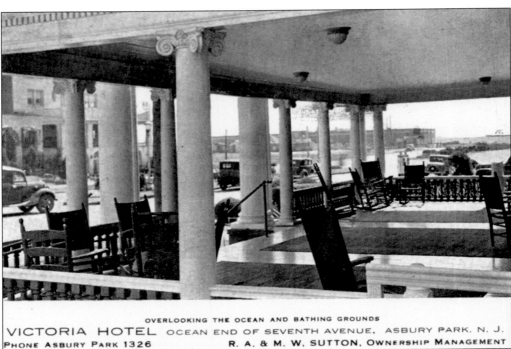

OVERLOOKING THE OCEAN AND BATHING GROUNDS

VICTORIA HOTEL OCEAN END OF SEVENTH AVENUE, ASBURY PARK, N. J.
PHONE ASBURY PARK 1326 R. A. & M. W. SUTTON, OWNERSHIP MANAGEMENT

VICTORIA HOTEL. The Victoria's wide porch with rocking chairs beckons visitors from the city to spend a nice, relaxed summer on the porch.

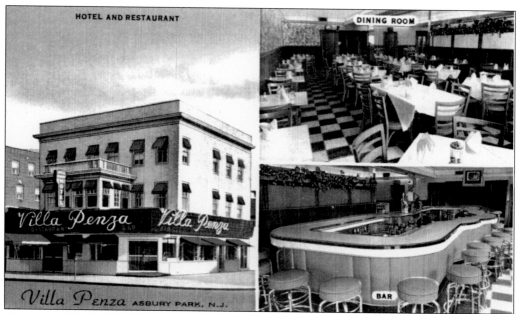

HOTEL AND RESTAURANT

VILLA PENZA. The Villa Penza bar, restaurant, and hotel was located at 238 Cookman Avenue, a block from the boardwalk, in the center of the theater district. Established in 1923, the year-round hotel served the best of Italian–American foods and the finest of liquors, with a large selection of wines and champagnes. Gavin Vecchione and sons were the owner-managers.

UNTITLED. An advertisement on the back of this Hotel Waverly postcard claims: "Hotel Waverly, where life is so restful! . . . Exceptionally good service makes every day a delight. Conveniently located near the beach, where wonderful bathing is had. Churches and theatres are many. Only 50 miles from New York."

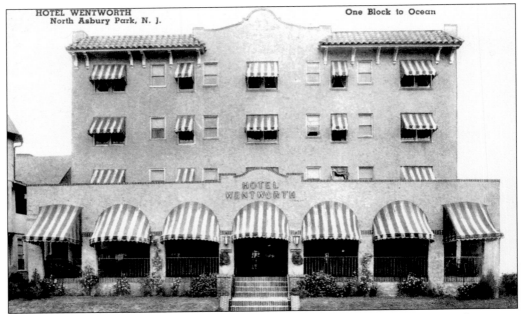

HOTEL WENTWORTH. The Hotel Wentworth, located at 203 Seventh Avenue, on the corner of Kingsley Street, was fireproof and famous for its good food—two big selling points with consumers. The hotel was owned and managed by Vincent Wentworth Layton and Mr. and Mrs. J. B. Layton.

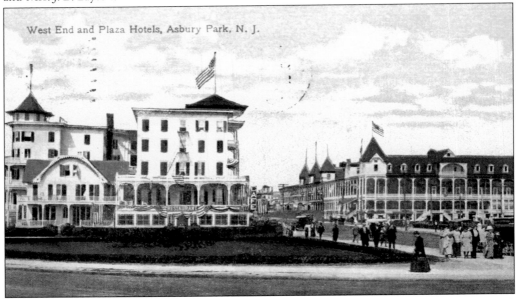

WEST END AND PLAZA HOTELS. This postcard view includes the Plaza Hotel (foreground, left) and the West End Hotel (right). Located at 201 Asbury Avenue, the West End Hotel was bought in 1898 by former Asbury Park mayor Frank Ten Broeck. In 1906, several renovations were made by the Ten Broeck family. The first-floor drugstore was removed, and an à la carte restaurant was installed. J. W. Richardson, son-in-law of Ten Broeck, installed five regulation-size Brunswick-Balke bowling lanes for guests to use.

Hotel White Swan

307 SUNSET AVENUE
ASBURY PARK

In the Heart of the Best Hotel District, Bordering the Select Residential Section. On the Shore of Sunset Lake, and Overlooking the Atlantic Ocean.

The Home Away From HOME

**Your Pleasure Assured
Your Comfort Looked After**

Under Management
CAPT. JOSEPH JENNINGS

HOTEL WHITE SWAN. The Hotel White Swan, at 307 Sunset Avenue, near Webb Avenue, was in the heart of the best hotel district and bordered on the select residential section. On the shore of Sunset Lake, the hotel also had ocean views. It was managed by Capt. Joseph Jennings.

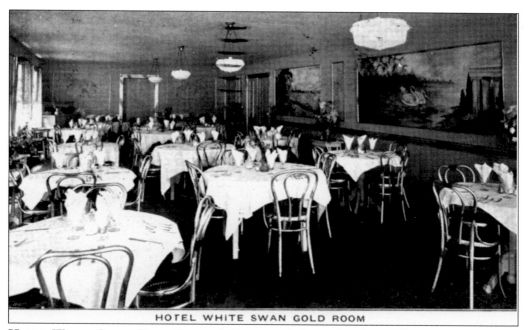

HOTEL WHITE SWAN GOLD ROOM

HOTEL WHITE SWAN GOLD ROOM. This postcard shows the elegant dining room, ready to receive guests. The postmark on this card is August 15, 1931.

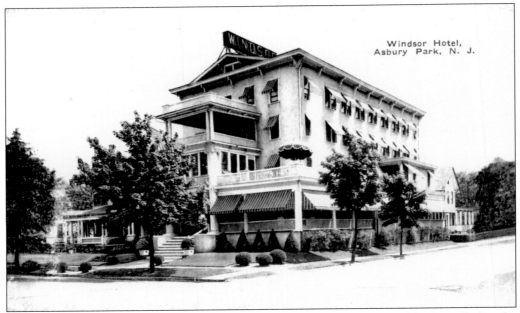

Windsor Hotel,
Asbury Park, N. J.

WINDSOR HOTEL. Located at 308 Third Avenue and owned and managed by Bert Crelin, the Windsor Hotel was refined, modern, and central to outdoor sports, the beach, and the boardwalk. The year-round hotel featured large sun decks and spacious porches.

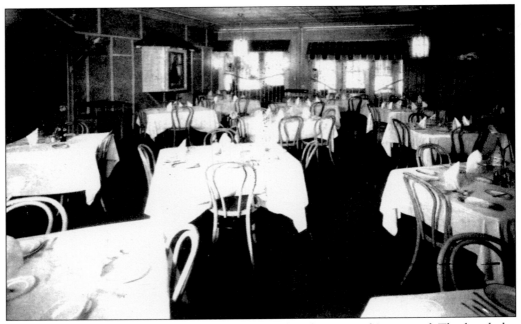

UNTITLED. The dining room of the Windsor Hotel is shown on this postcard. The hotel also featured a coffee shop and soda fountain.

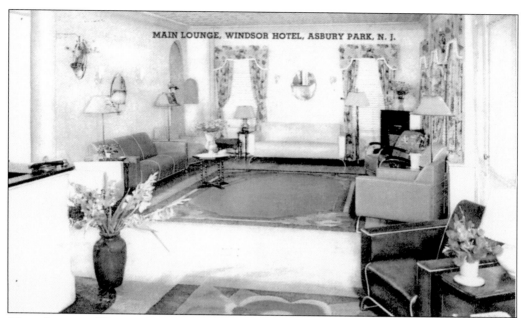

MAIN LOUNGE, WINDSOR HOTEL. This postcard shows the attractive modern lounge that was open to all the hotel guests.

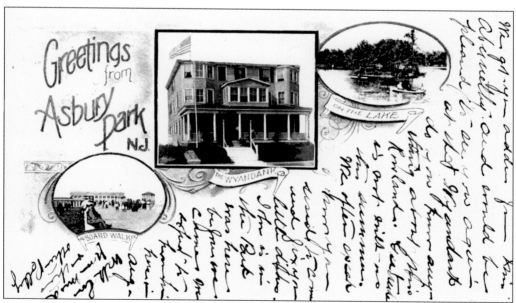

GREETINGS FROM ASBURY PARK. This promotional postcard shows a view of the Wyandank Hotel between scenes of the lake and the boardwalk. The postmark is August 23, 1907.

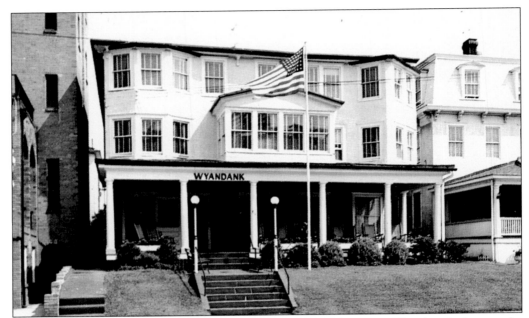

UNTITLED. The Hotel Wyandank was located at 215 Third Avenue. The description on the back of this postcard reads: "Overlooking the ocean, and conveniently located a block and one-half from the beach and boardwalk. Cool spacious porch with comfortable chairs for true relaxation. Sun parlor on second floor. Clean, cool bedrooms. Rates moderate and are adjusted to the times. Mr. and Mrs. Frank S. Morris, owner/managers."

UNTITLED. Zizos Inn, at 618 Asbury Avenue, featured rooms and apartments with private baths. Mrs. P. Zizos was the owner-manager. The inn was open all year.

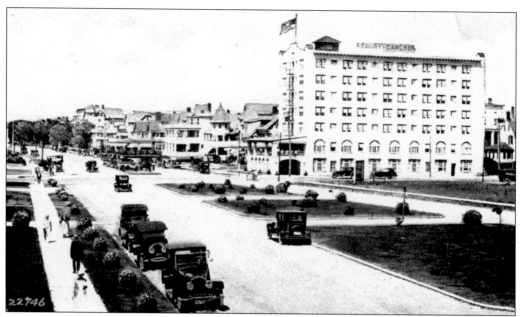

SEVENTH AVENUE SHOWING ASBURY CARLTON HOTEL. The Asbury Carlton Hotel, at 201 Seventh, on the corner of Ocean Avenue, featured an automatic fire sprinkler system and an elevator. The postmark on this card is August 6, 1925.

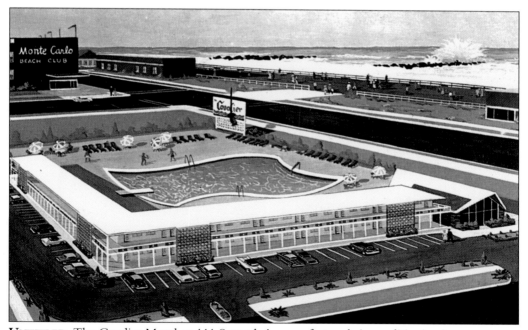

UNTITLED. The Cavalier Motel, at 111 Seventh Avenue, featured air conditioning in every room, as well as a television, a phone, and heat. The motel offered a patio, a coffee shop, a pool with free chaise lounges, and use of the nearby Monte Carlo pool.

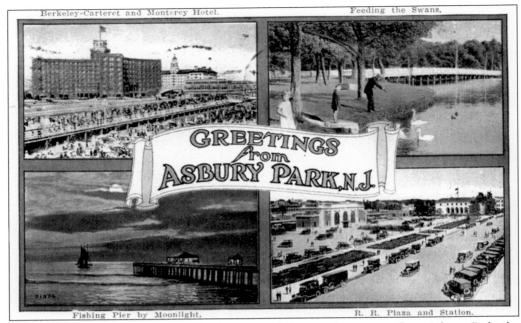

GREETINGS FROM ASBURY PARK. This postcard features four scenes from Asbury Park: the Berkeley Carteret and Monterey Hotels; feeding the swans on Deal Lake; the fishing pier by moonlight; and the railroad station.

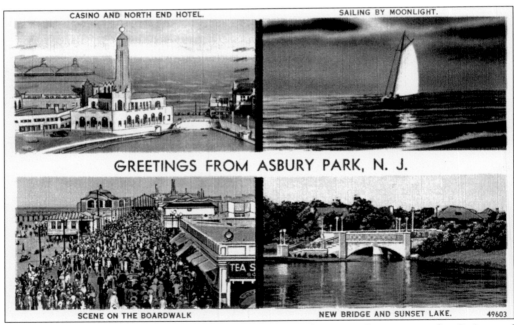

GREETINGS FROM ASBURY PARK. This postcard shows four waterfront scenes: the Casino and Ocean Grove's North End Hotel; sailing by moonlight; the boardwalk; and the new bridge and Sunset Lake.

Two

ON THE WATERFRONT

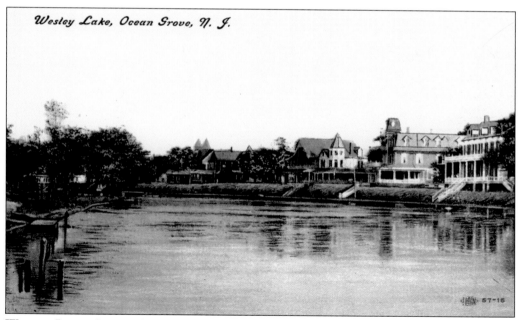

Wesley Lake, Ocean Grove, N. J.

WESLEY LAKE, OCEAN GROVE. Originally known as Long Pond, the lake was renamed for the founder of Methodism, John Wesley. It was once tidal, extending westward to beyond the railroad tracks, a short distance northward along what is now Grand Avenue. The Lake View House abutted the commercial area that was centered on Main Street, extending a short distance north and south of Cookman Avenue. In the lake was Fairy Island, a tiny piece of land near the Ocean Grove side, where the lake now ends (at the boulevard cutoff). The island was reached by a rustic bridge. Wesley Lake forms the border between Asbury Park and Ocean Grove.

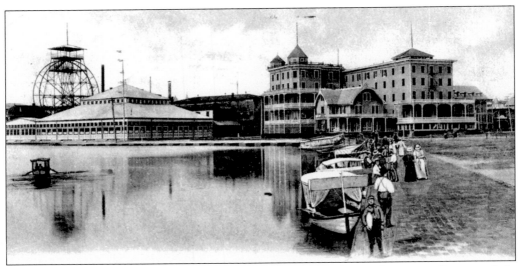

WESLEY LAKE WITH PLAZA HOTEL. In the early 1880s, the Heck Avenue ferry regularly crossed Wesley Lake on its way to and from Ocean Grove. The ferry was operated by Edward T. Knight, grandfather of Judge J. Edward Knight. The new bridge over the lake destroyed the ferry business. The Emory Street and Heck Avenue bridges across the lake had toll booths that charged 1¢ for each person to cross. On July 18, 1900, law student Walter Taylor refused to pay the toll. After that, tolls were abolished. One tollbooth was moved to the northwest corner of Grand and Sunset Avenues, where it served as a shelter for police officers. The postmark on this card is August 28, 1905.

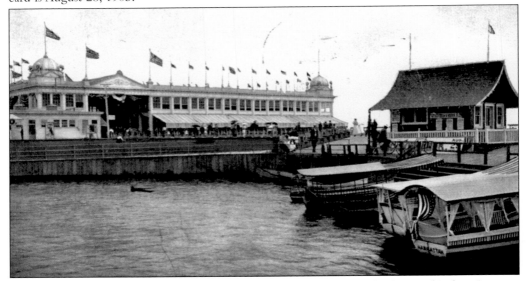

WESLEY LAKE BOAT FLOATS AND CASINO. The first wooden bridge at this location was erected in the fall of 1878 at Emory Street. Concrete footbridges costing $35,000 were opened on May 20, 1932, and are still in use. In the 1880s, there were carnivals in August, with boat races and a marine parade at night. Boats were decorated and disguised as warships, gondolas, Nile barges, and Chinese junks. Grandstands were erected along the shore, and Japanese lanterns hung from porches. In the early 1890s, founder James A. Bradley introduced 16 swan boats that were side-wheelers propelled by cranks. The postmark on this card is July 20, 1910.

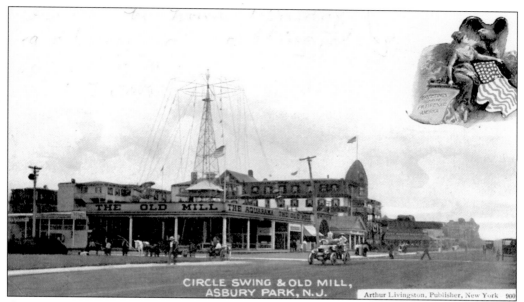

CIRCLE SWING AND OLD MILL. One of the first amusements was the circle swing across from Wesley Lake. The swing was replaced by the observation tower, where people would ride to the top and get out on the observation deck to view the city, Ocean Grove, and the nearby Atlantic Ocean. The final replacement was the Ferris wheel, with cars named for cities in New Jersey. This card was postmarked in July 1907.

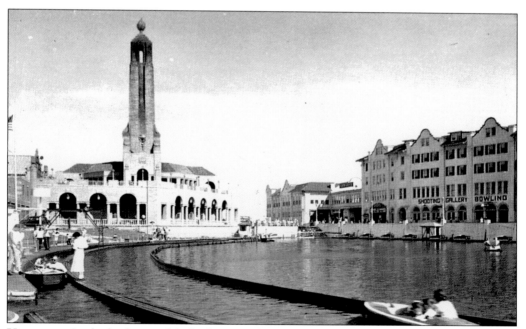

UNTITLED. In the background is the heating plant that furnished utilities to all the buildings on the boardwalk. On the right side of the Wesley Lake is Ocean Grove and its hotels along the lake. Powerboats were rented, and people could run the boats only inside the tracks on the Asbury Park side of the lake.

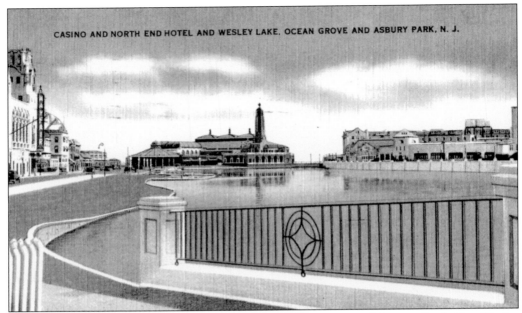

CASINO AND NORTH END HOTEL AND WESLEY LAKE. Viewed from a footbridge, Wesley Lake looks very calm and peaceful. On the left is the beautiful Mayfair Theatre. In the center is the power plant, and to the right are some of Ocean Grove's hotels. The postmark on this card is July 15, 1938.

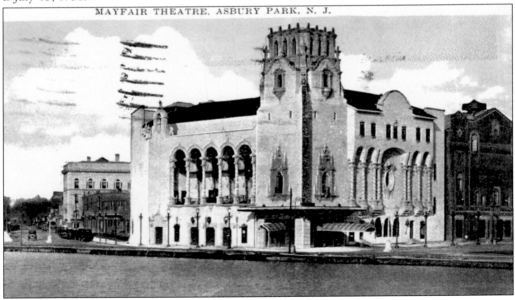

MAYFAIR THEATRE, ASBURY PARK, N. J.

MAYFAIR THEATRE. Built in 1927 and opened the same year with an art deco motif, the St. James Theatre, on Cookman Avenue, was a showplace that had 1,800 seats and a full stage. Construction on the Mayfair (next door to the St. James) began in 1927. Called "the Spanish Castle" when it opened in 1928, the Mayfair was built in a Moorish style. Clouds seemed to roll across the ceiling with tiny light bulbs simulating stars. Both theaters were closed in 1973 and razed a year later. The properties are still empty. The postmark on this card is August 7, 1928.

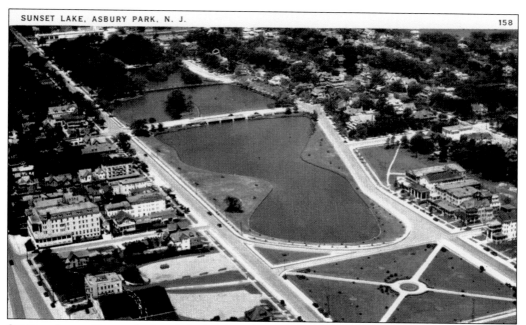

SUNSET LAKE. Postmarked on July 8, 1937, this card offers an aerial view of Sunset Lake. The wide Fifth and Sunset Avenues flank the lake.

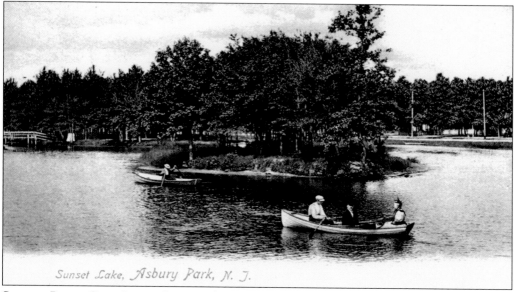

Sunset Lake, Asbury Park, N. J.

SUNSET LAKE. Canoeing on Sunset Lake was a favorite pastime of residents as well as summer visitors. The canoes in the postcard are going past St. John's Island.

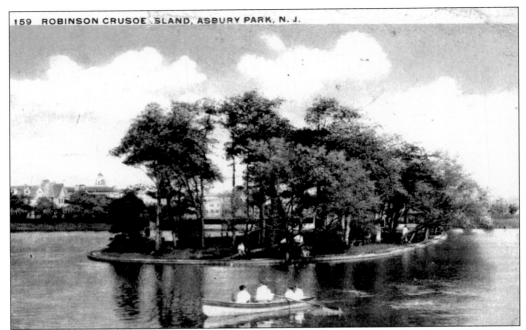

ROBINSON CRUSOE ISLAND. Founder James A. Bradley, the "first" to explore the uninhabited tract of land, had a romantic vision of himself as Robinson Crusoe and named the center island after the fictionalized explorer. The island covers less than one acre. Its name was later changed to St. John's Island because it reminded Ocean Grove pastor E. H. Stokes of the Isle of Patmos and the apostle John's experiences there. This card was postmarked on August 17, 1920.

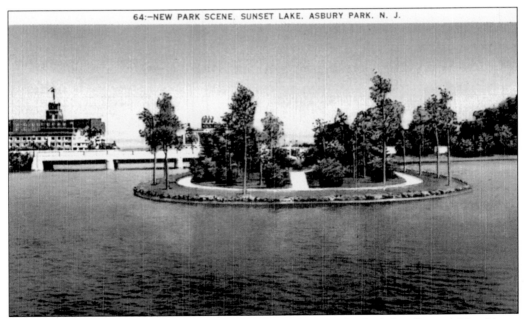

64:—NEW PARK SCENE. SUNSET LAKE. ASBURY PARK. N. J.

NEW PARK SCENE, SUNSET LAKE. In this view looking east, the Berkeley Carteret Hotel is on the left. St. John's Island is in the center.

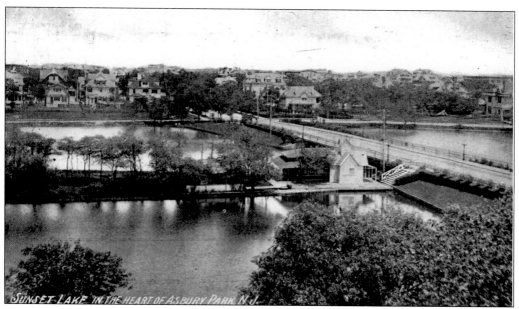

SUNSET LAKE IN THE HEART OF ASBURY PARK. At one time, St. John's Island boasted a boat livery and an ice-cream garden. A rustic bridge connected the island to the mainland. Before the bridges were built, rowboat ferries operated and transported people from shore to shore and back and forth to the island. Once the bridges were built, there were tolls to cross over the bridges at Grand Avenue and Emory Street. This card was postmarked on August 5, 1910.

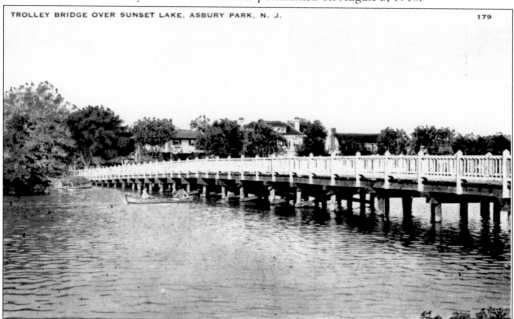

TROLLEY BRIDGE OVER SUNSET LAKE, ASBURY PARK, N. J. 179

TROLLEY BRIDGE OVER SUNSET LAKE. In 1888, the Emory Street bridge was rebuilt to carry the new streetcar tracks of the Seashore Electric Railway. It was rebuilt again in 1945 to remove the unused trolley tracks. Of the three lakes, Sunset Lake is the only one located inside Asbury Park.

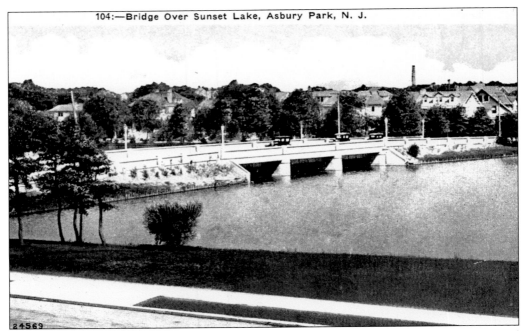

BRIDGE OVER SUNSET LAKE. In this *c.* 1930s postcard, motorcars are seen crossing the Grand Avenue bridge over Sunset Lake.

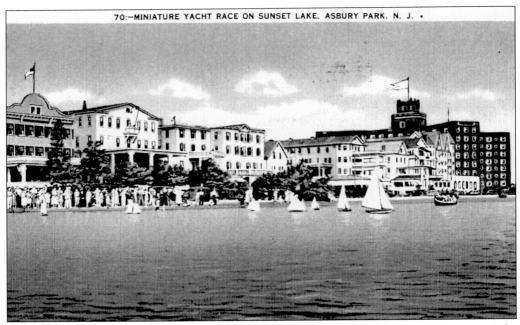

MINIATURE YACHT RACE ON SUNSET LAKE. A very popular summer pastime on Sunset Lake was the miniature yacht racing. The Berkeley Carteret Hotel and other large hotels are in the background. This card bears a postmark of July 19, 1940.

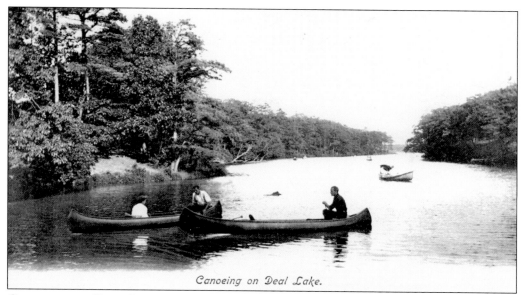

Canoeing on Deal Lake.

CANOEING ON DEAL LAKE. During the summer of 1896, a water toboggan chute was erected near the entrance to Interlaken. It had three tracks—two for downward boats and one to return the boats to the top. Founder James A. Bradley organized the Athletic Grounds along Deal Lake. In the 1920s, it became the high school's football field.

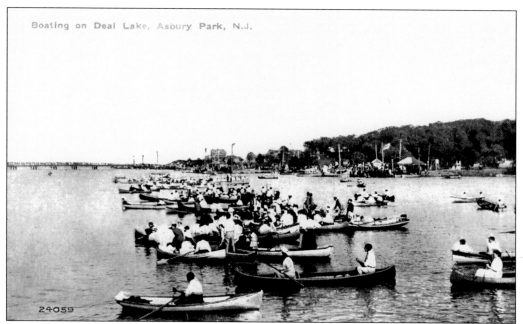

Boating on Deal Lake, Asbury Park, N.J.

24059

BOATING ON DEAL LAKE. Asbury Park shares Deal Lake as a border with Loch Arbor, Interlaken, Wanamassa, Allenhurst, West Allenhurst, and Deal. This card was postmarked on September 20, 1910.

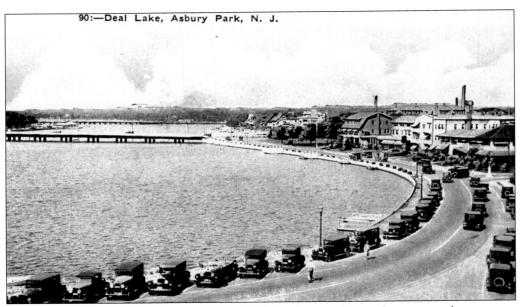

DEAL LAKE. On Revolutionary War maps, White's Pond was a saltwater bay open to the ocean—a natural inlet. In subsequent years, the lake was referred to as Boyleston Great Pond (1873), Corlies Pond, and Deal Lake (1889). During a blizzard on March 19, 1892, the four-masted square rigger *Windermere* beached at the foot of Deal Lake Drive. For 10 days, the ship provided a spectacle for the public. It was refloated on March 29.

Asbury Park, N. J.

CROWS' NEST, DEAL LAKE. At the intersection of Eighth Avenue and Deal Lake Drive (formerly known as Oak Bluff Drive), founder James A. Bradley erected the Crow's Nest, a public open-air pavilion, before the development of the northern portion of Asbury Park. The pavilion was located at what would become 614 Eighth Avenue after Deal Lake Drive was cut through. The Sea Shore Electric trolley turned off of Eighth Avenue onto Oak Bluff Drive and went right past the Crow's Nest. Bradley built a children's open-air gymnasium on the property that was outfitted with a castoff lion's cage and fire engine on which the children could play. These "toys" were rotated with boats and carriages that Bradley kept on the beach.

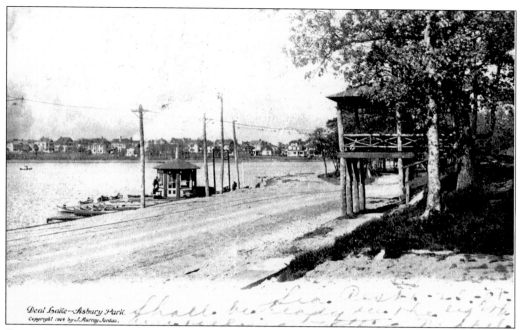

DEAL LAKE. Postmarked on June 26, 1908, this card shows the Crow's Nest and the boat ferry dock.

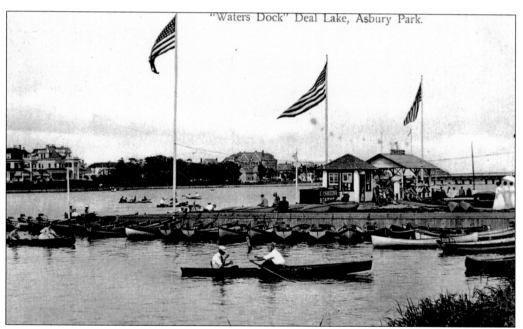

"WATERS DOCK," DEAL LAKE. From the 1890s into the 1930s, Deal Lake was a center of canoeing and boating. At one time, nine boat liveries were in business. Before 1890, only rowboats and punts were on the lake. Once an inlet, Deal Lake has three prongs that extend westward along 26 miles of tree-fringed shorelines.

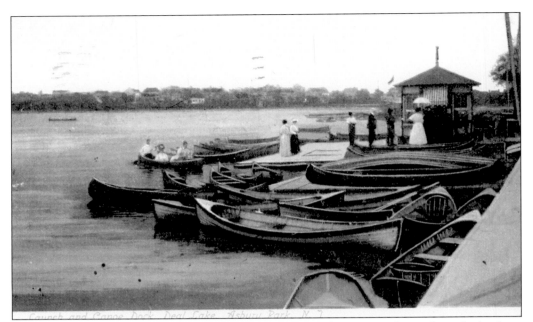

LAUNCH AND CANOE DOCK, DEAL LAKE. The postcard shows one of many boat docks along the shores of Deal Lake. The postmark on this card is September 26, 1907.

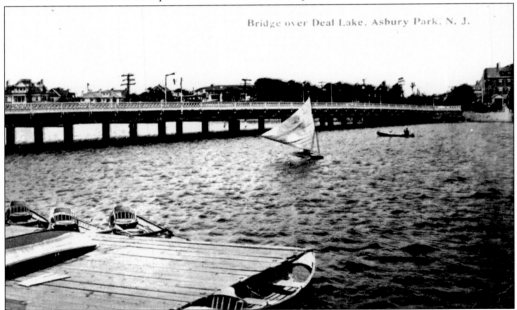

BRIDGE OVER DEAL LAKE. In 1895, the Atlantic Coast Electric Railroad crossed Deal Lake from Asbury Park northward to Long Branch. A 45-foot bridge was constructed across the lake at Main Street for the exclusive use of trolley lines. The bridge was designed and built by Asbury Park's Robert Sloan, who also built the elevated railroads in Chicago and New York. The first trolley to cross the bridge departed from the Steinbach's store at 5:45 p.m. on July 27, 1895. The fare from Asbury Park to Deal (one of the stops along the route) was 5¢. This card was postmarked on August 2, 1913.

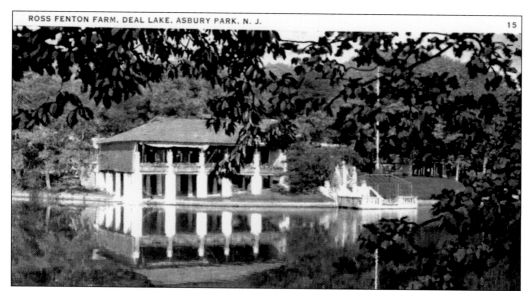

ROSS FENTON FARM, DEAL LAKE. On the south branch of Deal Lake was the Ross Fenton Farm, one of the nation's top nightclubs. In the late 1920s and early 1930s, young people would canoe to the club to listen to a free concert. One evening at dusk, a seaplane carrying torch singer Helen Morgan landed on the lake, close to the club where she was to perform. No canoes were sunk, but a lot of people were wet and angry. Ocean Township police issued the pilot a summons. This card bears a postmark of September 15, 1931.

ROSS FENTON FARM. James J. Corbett, known as Gentleman Jim, came to the shore to live and train after he knocked out John L. Sullivan in 1892 in New Orleans for a purse of $25,000. Corbett trained briefly at 318 Eighth Avenue. He often strolled the boardwalk with Mayor Frank Ten Broeck and other city officials. Sullivan kept in shape by rowing on Deal Lake, swimming in the ocean, and biking on the boardwalk. Corbett staged a benefit boxing exhibition on September 1, 1892, in Fred J. Long's Park Opera House, on the northeast corner of Bangs and Emory Avenue. Proceeds went to lifeguards. Corbett and his wife kept a house on the southeast corner of Seventh and Emory Avenues. In 1893, Corbett set up a training camp on Deal Lake at R. R. "Pop" Hulick's farm, which later became the Ross Fenton Farm. This card is postmarked September 3, 1907.

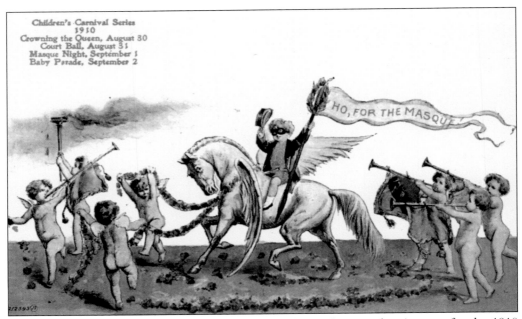

CHILDREN'S CARNIVAL SERIES 1910. This postcard served as an advertisement for the 1910 Baby Parade on the Asbury Park boardwalk. The postcard reads, "The parade queen will be crowned on August 31, there will be a Masque Night on September 1, and the Baby Parade will be September 2."

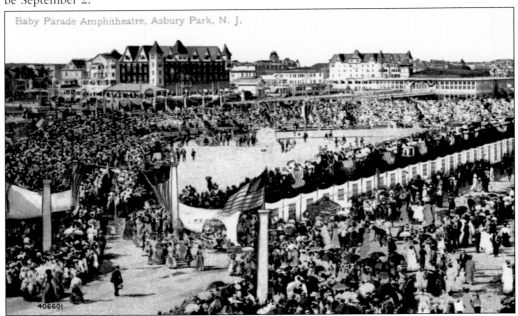

BABY PARADE AMPHITHEATRE. Started on July 21, 1890, by founder James A. Bradley, the first Baby Parade featured 165 carriages containing 178 babies being pushed by their mothers. According to the *Asbury Park Press*, George W. Jacobs (the son of theatrical manager H. R. Jacobs of New York) was a flag bearer. Twins Harold and Frank Vaughan led the parade, following Officer Whitle and the Marine Band.

Baby Parade, Asbury Park, N. J.

BABY PARADE. This postcard shows the parade of babies on Ocean Avenue. In 1890, police chief Caleb T. Bailey suggested to James A. Bradley that the large number of parents pushing baby carriages on the 15-foot-wide boardwalk could be turned into a parade. Bradley liked the idea and notified the *Asbury Park Press* that there would be a parade and that prizes were to be awarded to certain winners. Each of the 178 children received a box of candy, and the winner received a tiny cup. The next year, there were 380 entrants, and the boardwalk was roped off. In addition to baby coaches, there were bicycles, cradles, go-carts, and other vehicles. In a few years, pony carts and elaborate floats made their appearance.

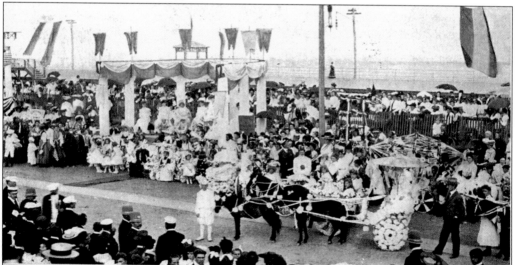

BABY PARADE. This card shows how elaborate the Baby Parade had become, with flower-decorated pony carts and a grand reviewing stand. In 1901, the parade moved from the boardwalk to Ocean Avenue, and a grandstand was built. The first prize ever given was a baby carriage donated by John Githens, a furniture dealer. Before the final parade in 1931, the prizes were automobiles and college scholarships. Prizes were awarded for the most handsome carriage, the most unique, the most original, and the most grotesque decoration. This card was postmarked on August 31, 1906.

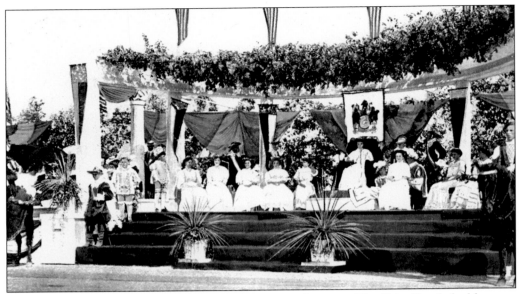

THE QUEEN AND HER ATTENDANTS AT THE BABY PARADE. The Baby Parade had become a big tourist attraction, so there were now royal courts to judge the contestants. In the 1920s, the late-summer event used to draw more than 150,000 people. The Great Depression killed the parade. In 1946, city officials tried to bring it back and did so for three years. It failed for a final time and never returned. In 1924, Gladys V. Trowbridge reigned as Queen Titania XXXIII in the Baby Parade. Evelyn Kane was Princess Flora. Helen Golden was Princess Cinderella. Delores Degarcia was the director of parade pageants. The parade's director, Harry Jones, was the master of ceremonies at all carnival events.

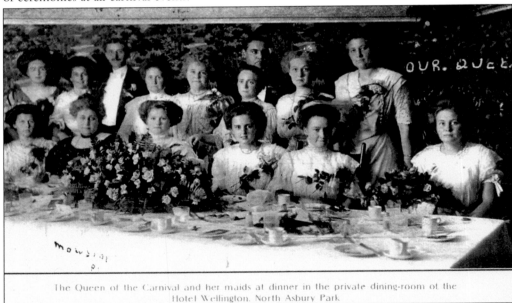

The Queen of the Carnival and her maids at dinner in the private dining-room of the Hotel Wellington. North Asbury Park

THE QUEEN OF THE CARNIVAL AND HER MAIDS. The North Asbury Wellington Hotel took full advantage of the Baby Parade by having the royal court stay at the hotel, and by advertising the event through postcards. This card bears a postmark of August 7, 1909.

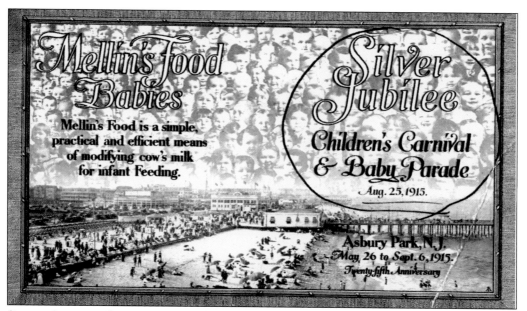

SILVER JUBILEE. Commemorating the 25th anniversary of the Baby Parade, an enterprising sponsor, Mellin's Food, ties in its milk product with the parade. The postmark on this card is August 21, 1915.

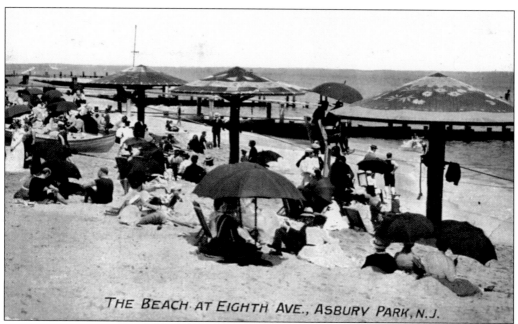

THE BEACH AT EIGHTH AVE., ASBURY PARK, N.J.

THE BEACH AT EIGHTH AVENUE. The beachgoers have a few umbrellas to protect themselves from the sun, but they do not compare to the big, colorful umbrellas that are attached to the bathing-rope poles. This card was postmarked on August 26, 1907.

ARTHUR PRYOR, BANDMASTER. Born September 22, 1870, in St. Joseph's, Missouri, Arthur Pryor was the son of a bandleader. In his teens, Arthur could play trombone, cornet, alto horn, bass viol, and piano. He joined the band of "March King" John Philip Sousa and, in 1903, formed his own band. Pryor was the principal attraction on the Asbury Park beachfront from 1904 to 1930 and retired in 1934. He composed 250 marches, novelties, and tone poems, as well as three light operas. Pryor was the best trombone virtuoso in the world. In 1934, he was elected to the Monmouth County Board of Freeholds as a Democrat and served one term. He died of a stroke on June 18, 1942.

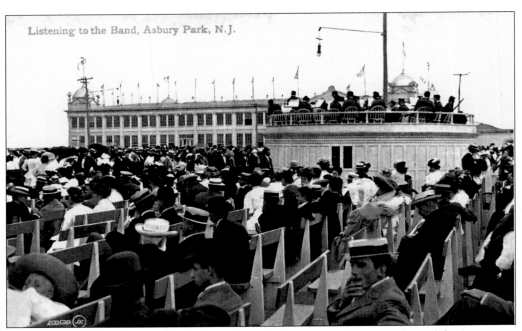

Listening to the Band, Asbury Park, N.J.

LISTENING TO THE BAND. This is the bandstand where Arthur Pryor performed for 30 years as conductor. The bandstand was built on the boardwalk at the end of the fishing pier.

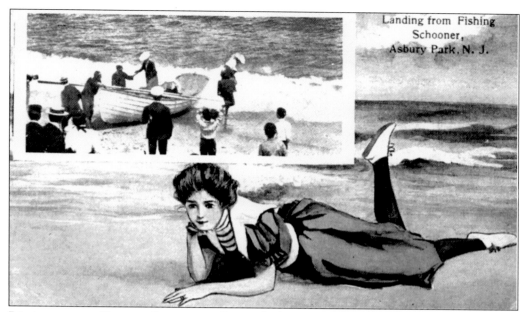

LANDING FROM FISHING SCHOONER. Postmarked on July 19, 1911, this card shows two views. One is of a young woman lying on the beach in her bathing costume. The second image shows a rowboat boarding passengers to be taken out to the schooner waiting beyond the breakers.

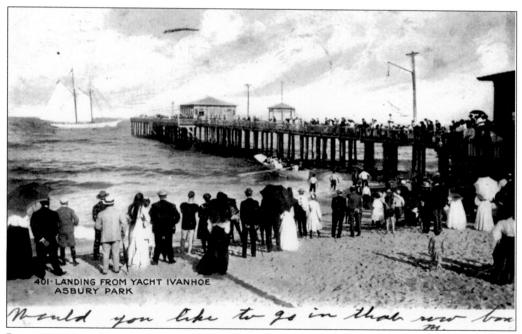

LANDING FROM YACHT *IVANHOE*. On September 14, 1944, a hurricane with a storm surge of 6.3 feet turned the fishing pier, restaurant, shooting gallery, and gift shop into rubble. Navy trainees at the Berkeley Carteret and Monterey Hotels served as security guards to prevent looting. The pier was not rebuilt. This card was postmarked on July 24, 1907.

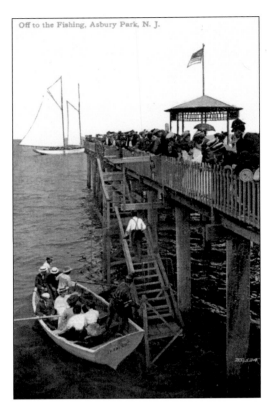

Off to the Fishing, Asbury Park, N. J.

OFF TO THE FISHING. Passengers are getting ready to be rowed out to the fishing boat. The boat was used for sightseeing purposes, sailing up and down the northern New Jersey shoreline. The fishing pier serves as a wait station for the next boat. This card bears a postmark of July 20, 1914.

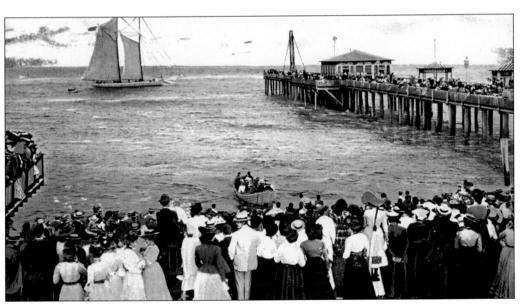

FISHING PIER. In this view, there are many hopeful passengers but few available boats. Both the pier and the beach are filled with customers eager to go sightseeing or fishing. The postmark is August 4, 1909.

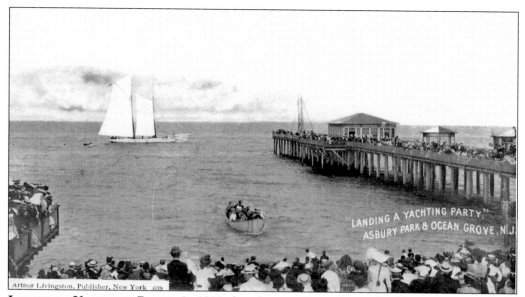

LANDING A YACHTING PARTY. In 1903, the schooner *Emma B*, captained by Harry H. Maddox, took passengers on fishing and sightseeing trips. Passengers were rowed out to the boat. During the summer, there were two trips daily from the Asbury Park beachfront. The *Emma B* was succeeded by *Carib*, also commanded by Maddox. Passengers embarked directly from the Asbury fishing pier at First Avenue. On August 14, 1893, the fishing schooner *Mary F. Kelly* wrecked at Sixth Avenue and four crew members died.

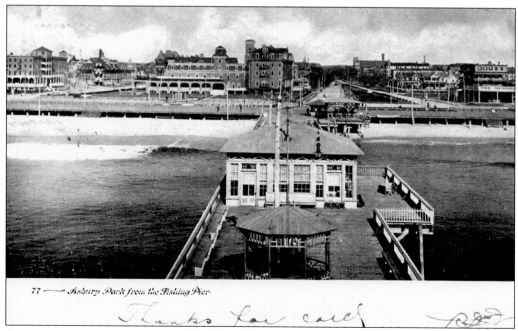

ASBURY PARK FROM THE FISHING PIER. This 1906 postcard presents a view of Asbury Park from the end of the fishing pier on First Avenue.

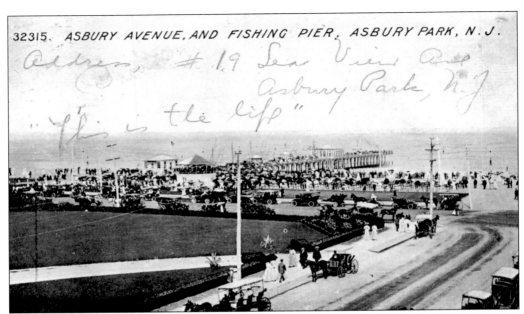

ASBURY AVENUE AND FISHING PIER. Just south of the fishing pier, the city built an elevated bandstand for outdoor entertainment. The postmark on this card is July 7, 1914.

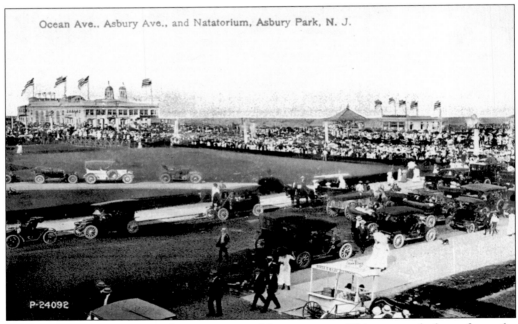

Ocean Ave., Asbury Ave., and Natatorium, Asbury Park, N. J.

P-24092

OCEAN AVENUE, ASBURY AVENUE, AND NATATORIUM. This postcard dates from the beginning of the 20th century and shows Asbury Avenue intersecting with Ocean Avenue. There is an ice-cream wagon parked just off Asbury Avenue in the foreground. Ocean Avenue is very congested with what could be the Baby Parade. In the background on the left is the ornate, two-story natatorium, a public swimming pool with its own lifeguards and changing areas.

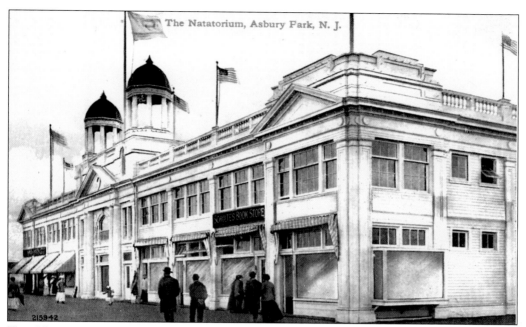

THE NATATORIUM. The first floor of the natatorium building housed Schulte's Book Store and other concessions. In April 1917, a fire caused by defective wiring broke out at the natatorium. Fed by strong east winds of 50 miles per hour, the blaze swept over to Grand Avenue. Firefighters fought bravely, even dynamiting one of the hotels as a firebreak, but the fire kept going, taking down one wooden structure after another. When the fire was finally subdued, the city had lost a four-block section of the hotel district.

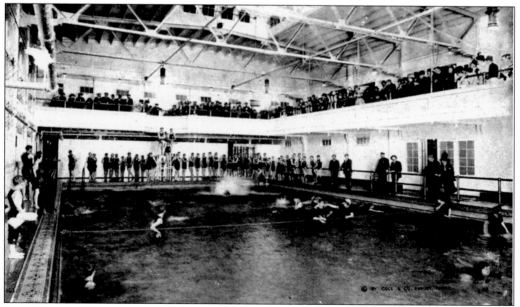

INTERIOR OF NATATORIUM. This postcard shows how massive the building was. The pool filled the interior, and paying visitors could watch swimmers from either the first level or the upper level. Three lifeguards are stationed at the deep end of the pool.

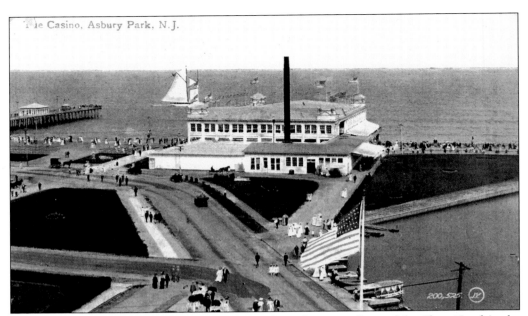

THE CASINO. This view was most likely taken from the upper floor of the Plaza Hotel in the early 20th century. It shows the fishing pier (extreme left), the wooden Casino (center), and Wesley Lake (right). In the background is the beautiful Atlantic Ocean.

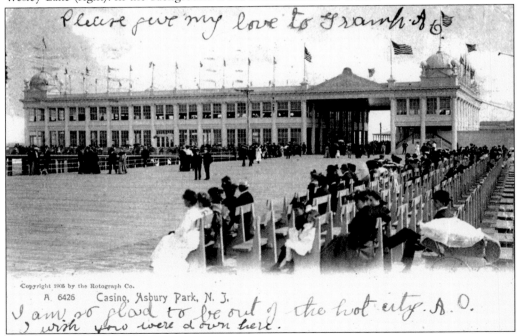

Please give my love to Frank A. E.

Copyright 1905 by the Rotograph Co.

A. 6426 Casino, Asbury Park, N. J.

I am so glad to be out of the hot city. A. O.
I wish you were down here.

CASINO. The original Casino is viewed from the Asbury Park side, looking through the opening into Ocean Grove. The boardwalk is very wide, with rows of wooden benches along the west side. Built at a cost of $60,000 in 1903, the Casino hosted the National Education Association convention in 1905. The Casino had seating capacity for 7,000 people, but 35,000 educators showed up for the convention. This card was postmarked on August 23, 1905.

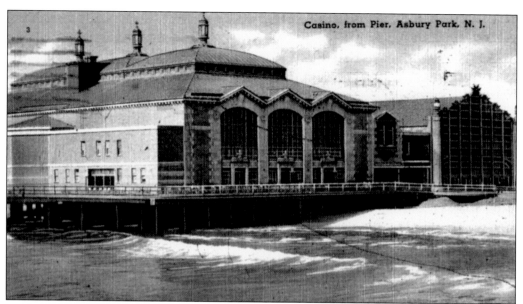

CASINO, FROM PIER. After a fire on January 12, 1928, destroyed the original wooden Casino, a new steel-framed Casino was built on the site of the burned-out building. The postmark on this card is August 21, 1944.

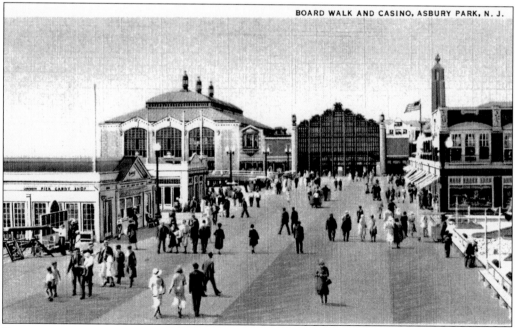

BOARDWALK AND CASINO. The Casino, seen here from Asbury Park, served as the border between Asbury Park and Ocean Grove. Where there were once rows of boardwalk benches looking out at the ocean there are now stores lining both sides of the wide boardwalk in this view. In the middle of the boardwalk is a rolling chair. The chairs were a wonderful money maker for the owners, as most visitors liked to cruise the boardwalk without too much effort. In the foreground on the left is the Pier Candy Shop, at the base of the unseen fishing pier.

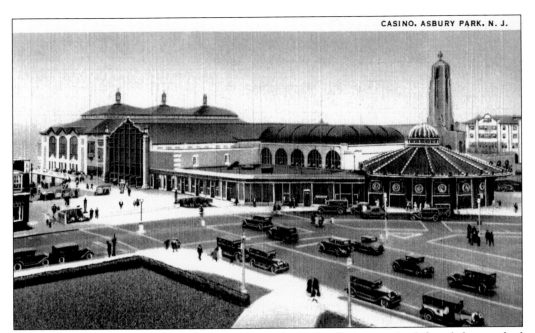

CASINO. This *c.* 1925 view from Asbury Avenue shows the Casino on the left and the attached concessions extending to Asbury Avenue. The merry-go-round is at the right end, facing Wesley Lake, with the power plant stack behind it. On the extreme right are the Ocean Grove hotels that face the lake. The postmark is July 8, 1942.

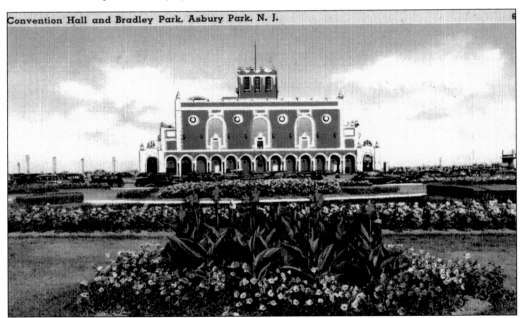

Convention Hall and Bradley Park, Asbury Park, N. J.

CONVENTION HALL AND BRADLEY PARK. Looking through the beautifully landscaped Bradley Park (named for founder James A. Bradley), one can see how symmetrically Convention Hall was designed and constructed. Out of frame to the left is the Berkeley Carteret Hotel. The card was postmarked on July 7, 1949.

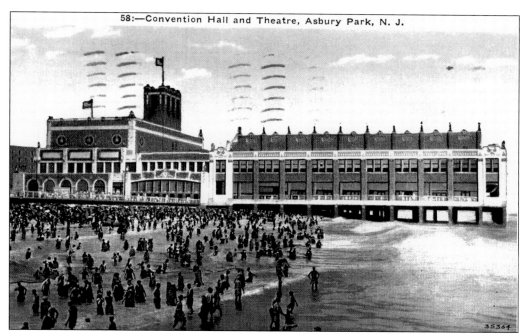

CONVENTION HALL AND THEATRE. Bathers on the Sunset Avenue beach could see the entire Convention Hall complex, which included the Palace Movie Theatre on the Ocean Avenue side. Convention Hall was opened to the public in 1930. The postmark on this card is September 5, 1936.

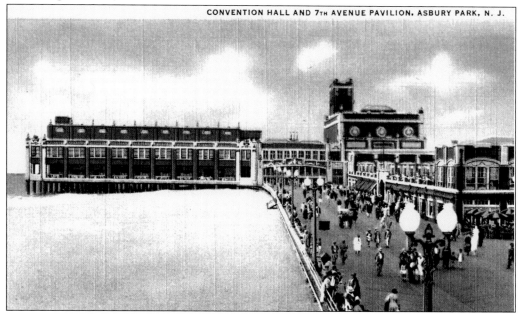

CONVENTION HALL AND 7TH AVENUE PAVILION, ASBURY PARK, N. J.

CONVENTION HALL AND SEVENTH AVENUE PAVILION. Dated March 13, 1945, this view of Convention Hall looks south from Seventh Avenue. The postcard publisher has removed the concessions from the east side of the boardwalk so that we might get a better look at Convention Hall.

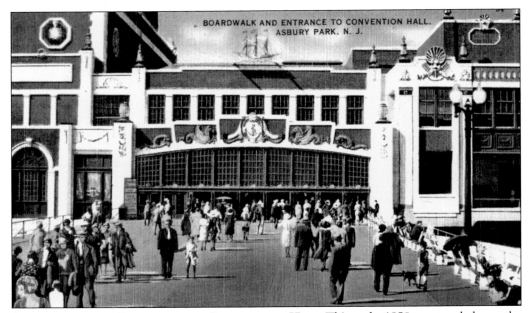

BOARDWALK AND ENTRANCE TO CONVENTION HALL. This early-1950s postcard shows the ornate decorations on the building. Seashells and sailing ships, as well as garlands and fantastic sea horses, adorn Convention Hall. This beautiful building still stands today.

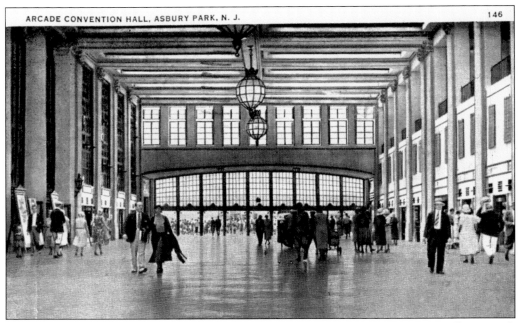

ARCADE CONVENTION HALL. Inside Convention Hall was a wide covered walkway with concessions on each side of the arcade. Out of the picture to the left is the entrance to the huge convention center, where sporting events (basketball and wrestling) were staged. Musical concerts were held in this room, and the top groups and orchestras in the world played in this hall. The postmark on this card is June 8, 1934.

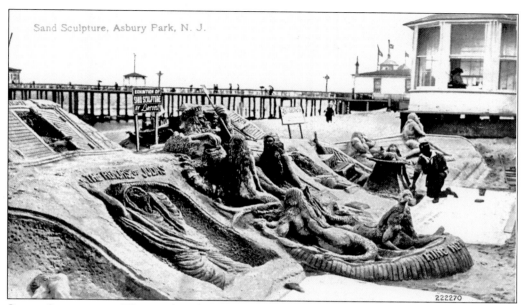

Sand Sculpture, Asbury Park, N. J.

SAND SCULPTURE. The sand sculpture artist Borent has designed and constructed several detailed sculptures seen here, including King Neptune surrounded by mermaids, "The Remorse of Judas," and many other fantastic creatures and objects. This view may date from the early 20th century, when the hotel district and the boardwalk were enjoying tens of thousands of summer visitors every season.

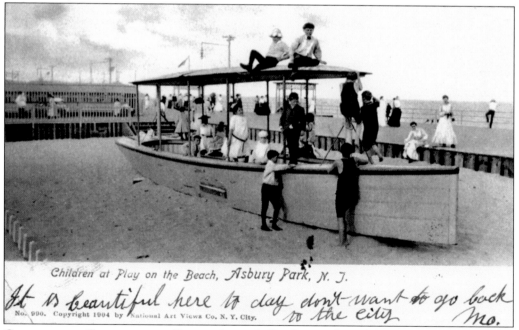

Children at Play on the Beach, Asbury Park, N. J.

It is beautiful here to day don't want to go back to the city. mo.

No. 990. Copyright 1904 by National Art Views Co. N. Y. City.

CHILDREN AT PLAY ON THE BEACH. James A. Bradley used to place fire engines, boats, lion cages, and other objects on the beach and at the Crow's Nest on Deal Lake for children to play on. The "toys" were rotated between the two locations so that the children were never bored. This card bears a postmark of May 16, 1907.

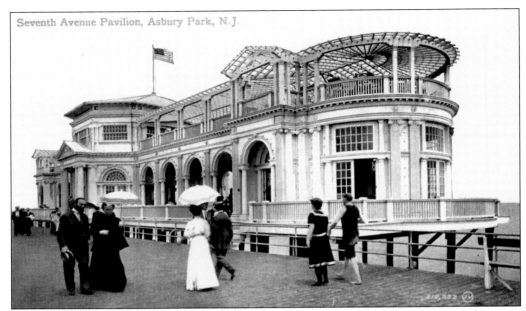

Seventh Avenue Pavilion, Asbury Park, N.J.

SEVENTH AVENUE PAVILION. In this *c.* 1900 view, two people in bathing costumes are walking on the boardwalk, alongside others in full dress of the day. They are all passing by the Seventh Avenue Pavilion, which was perched above the sand. The lovely structure was called "the bird cage" because of the latticework that adorned the top observation deck. The pavilion's many windows allowed people to look out over the ocean without being blasted by easterly winds.

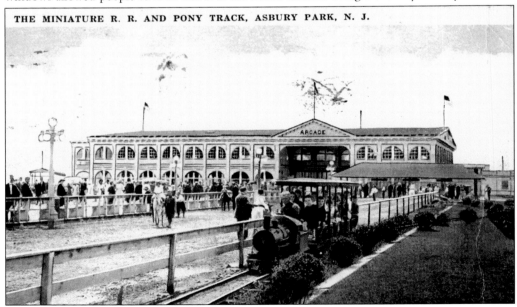

THE MINIATURE R. R. AND PONY TRACK, ASBURY PARK, N. J.

THE MINIATURE RAILROAD AND PONY TRACK. In the early 20th century, the city ran a miniature railroad on the west side of the boardwalk, strictly as an amusement for children. There was also a pony track, where ponies carrying children were led around the sand track beside the miniature railroad. Both attractions were very popular with children and their parents. This card bears a postmark of August 1, 1922.

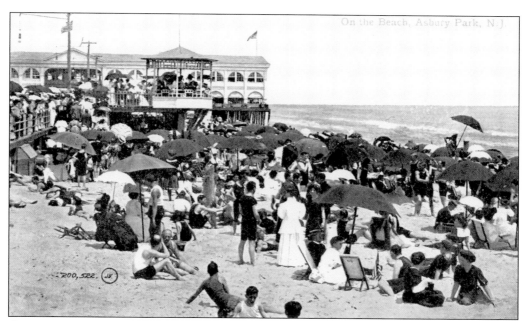

ON THE BEACH. Visitors to the beach between Fourth and Fifth Avenues were quite varied in their attire. Some were fully dressed, while others wore bathing costumes. People visiting the boardwalk had places to sit and watch the bathers. They could then venture into the Fifth Avenue Arcade for food and sundries. The postmark on this card is November 23, 1908.

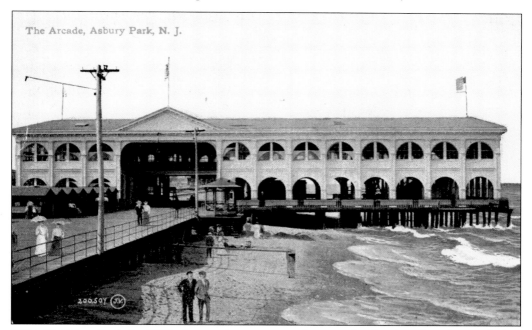

The Arcade, Asbury Park, N. J.

THE ARCADE. Built in 1905, the arcade was a popular spot for dancing, listening to Arthur Pryor's concerts, and sitting in the rocking chairs that overlooked the ocean. The beachfront property just to the north had the miniature railroad and the pony rides. It later became the site of Convention Hall.

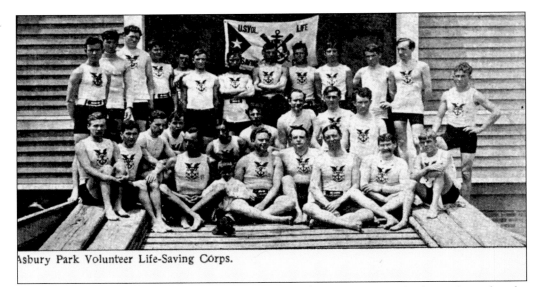

Asbury Park Volunteer Life-Saving Corps.

ASBURY PARK VOLUNTEER LIFE-SAVING CORPS. Life-saving station No. 6 was situated at the foot of Deal Lake. The first lifeguards were hired and paid by founder James A. Bradley.

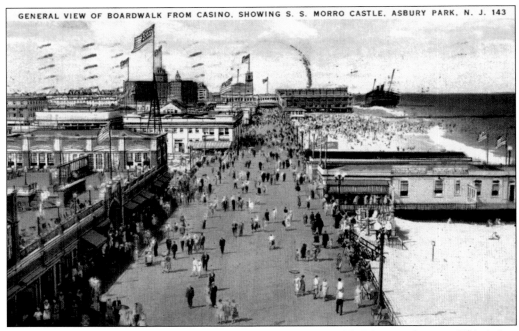

GENERAL VIEW OF BOARDWALK FROM CASINO, SHOWING S. S. MORRO CASTLE, ASBURY PARK, N. J. 143

GENERAL VIEW OF BOARDWALK FROM CASINO, SHOWING SS *MORRO CASTLE*. This is just one of the hundreds of postcards published when the *Morro Castle* ran aground on the beach outside Convention Hall in September 1934. The postmark is July 2, 1937.

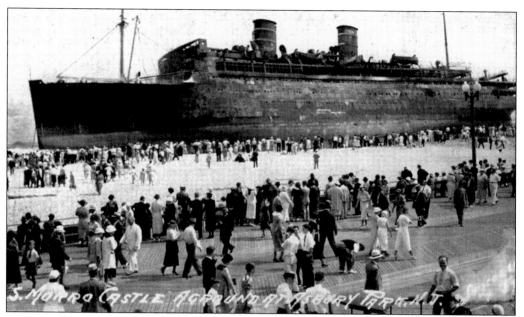

S. MORRO CASTLE AGROUND AT ASBURY PARK N.J.

UNTITLED. The *Morro Castle*, a luxury liner of the Ward Shipping Lines, was swept ashore at Asbury Park on Saturday, September 8, 1934, with the loss of more than 150 lives. The liner traveled exclusively between New York and Havana, Cuba, and had been doing so for four years when an early-morning fire broke out on the ship as it was about eight miles off the New Jersey coast.

Asbury Park. N. J.

UNTITLED. On the south end of the boardwalk were numerous rides for children of all ages to enjoy. This group of amusements featured the Sky Ride, which traveled above the boardwalk for several blocks.

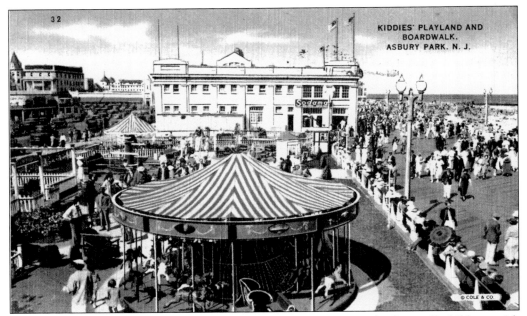

KIDDIES' PLAYLAND AND
BOARDWALK.
ASBURY PARK. N. J.

KIDDIES' PLAYLAND AND BOARDWALK. This playground is strictly for small children, with one exception. A small booth belonging to Madame Marie, the psychic acknowledged by Bruce Springsteen in his music, can also be seen. The postmark on this card is July 1943.

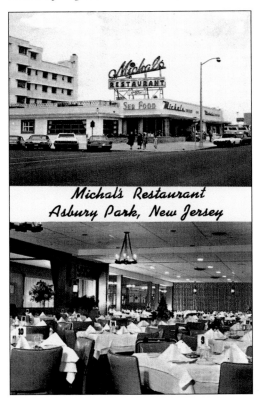

Michal's Restaurant
Asbury Park, New Jersey

MICHAL'S RESTAURANT. This restaurant on Second and Ocean Avenues was famous in the 1950s for delicious seafood. There were three dining rooms that seated from 25 to 300 people. The restaurant also offered a cocktail lounge and a coffee shop, and all the baking was done on the premises. Their motto was "Finest Quality."

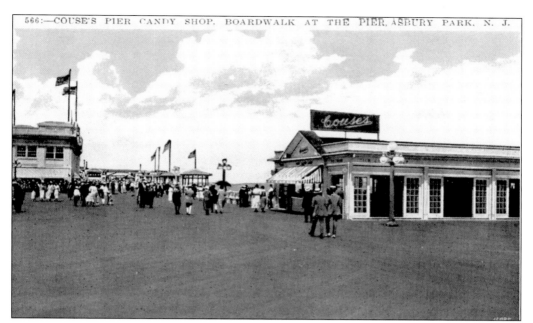

COUSE'S PIER CANDY SHOP, BOARDWALK AT THE PIER. Located on the boardwalk at the end of the fishing pier, Couse's Candy Shop was an equal to the Criterion Candy Store across the boardwalk. Couse's made its own candy, sold it in the store, and shipped it all over the world. On the card's reverse, the owners claim, "All our taffy is wrapped on a modern sanitary machine without being touched by hand."

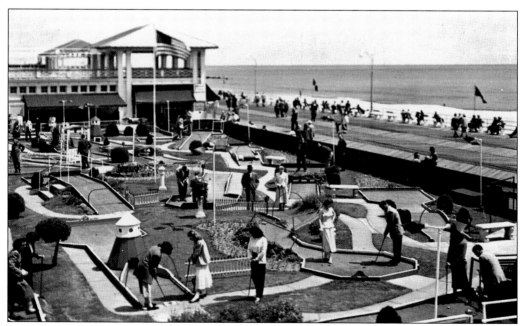

UNTITLED. This postcard from the 1950s shows the miniature golf course on the boardwalk on Fourth Avenue.

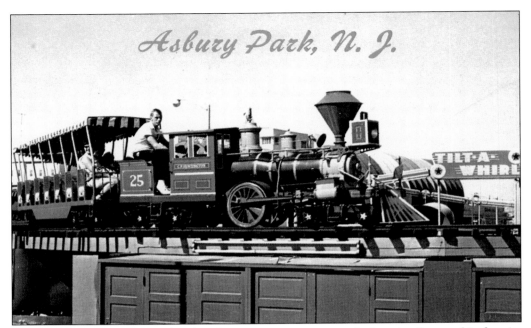

Asbury Park, N. J.

UNTITLED. The miniature railroad at the amusement center on the boardwalk was a big favorite with children and their parents. The operator sat at the controls of an authentic-looking steam engine, complete with a cowcatcher at the front of the engine.

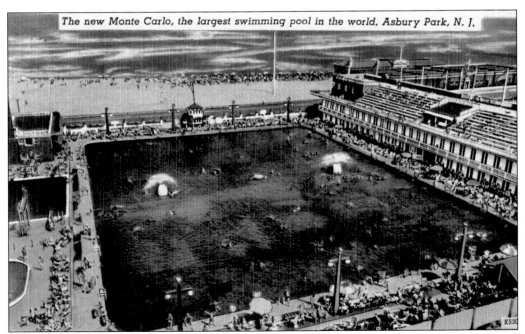

The new Monte Carlo, the largest swimming pool in the world, Asbury Park, N. J.

THE NEW MONTE CARLO, THE LARGEST SWIMMING POOL IN THE WORLD. Walter Reade's Monte Carlo pool was the largest construction job completed in Asbury Park during World War II.

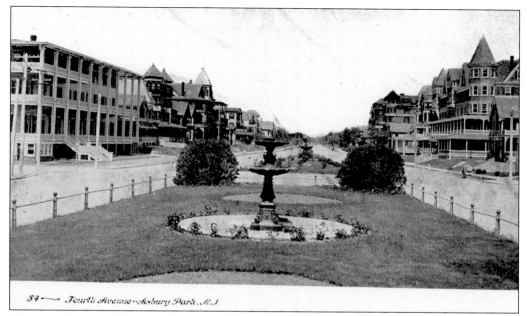

FOURTH AVENUE. This early-20th-century postcard shows the blocks of wooden hotels lining both sides of Fourth Avenue. In the middle of the avenue are small parks with flower beds and water fountains. Founder James A. Bradley loved having parks, large and small, for people to enjoy.

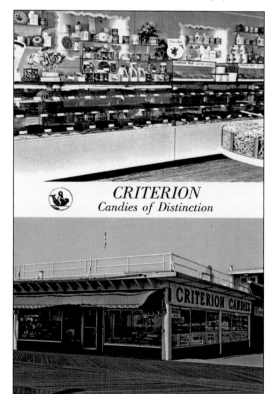

CRITERION, CANDIES OF DISTINCTION. This postcard shows the interior and exterior of the boardwalk candy store, the Criterion. The store made and displayed its own candy, which was shipped all over the world. Criterion was famous for its many flavors of saltwater taffy (which actually contained no salt water), but the store's fudge came in a close second to the taffy.

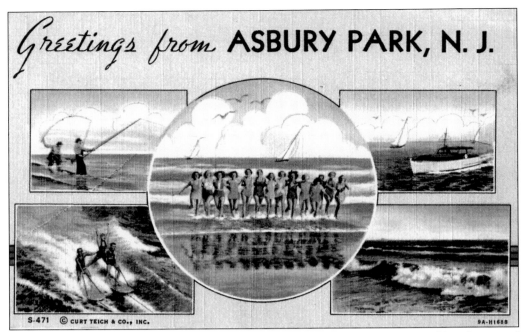

GREETINGS FROM ASBURY PARK. Surrounded by pictures of fishermen, water-skiers, boats, and ocean waves, 14 young women in 1930s bathing costumes frolic in the ocean.

GREETINGS FROM ASBURY PARK. Created around 1900, this "greetings" postcard shows young women in bathing costumes, playing tug of war in the water.

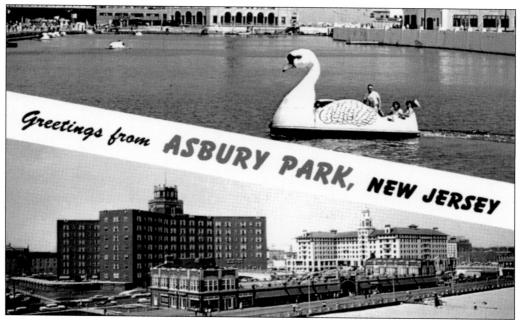

GREETINGS FROM ASBURY PARK. This *c.* 1960s postcard features a "greetings" banner and shows two famous scenes from the oceanfront. The upper image shows a swan boat gliding across Wesley Lake in front of the power plant and the Casino merry-go-round. The lower image shows the Berkeley and Monterey Hotels behind the boardwalk and the beach.

GREETINGS FROM ASBURY PARK. The letters of Asbury Park are filled with pictures from 1950s scenes, with the Berkeley Carteret Hotel and Convention Hall featured in several letters.

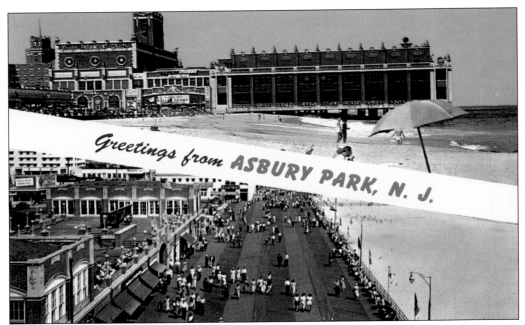

GREETINGS FROM ASBURY PARK. A banner splits two oceanfront scenes. Above are Convention Hall and the Paramount Theatre. Below are the south end of the boardwalk near the Casino and all the shops on the west side of Asbury Park's wide boardwalk.

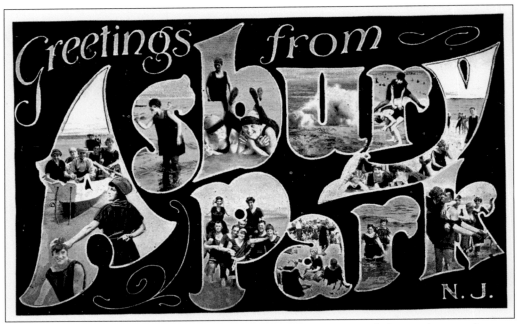

GREETINGS FROM ASBURY PARK. This early-20th-century postcard shows pictures of young men and women playing on the beach.

Three

DOWNTOWN

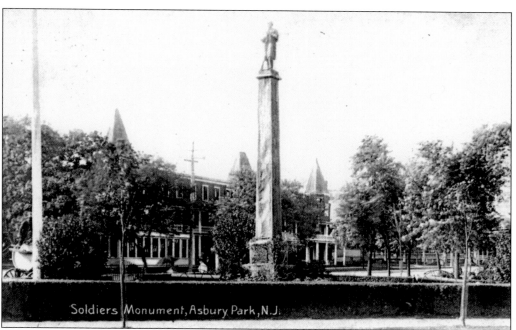

Soldiers Monument, Asbury Park, N.J.

SOLDIERS' MONUMENT. The original statue of a New Jersey 14th Regiment Civil War soldier was placed on the boardwalk by founder James A. Bradley in the 1870s. The statue was on a small pedestal, standing about 10 feet tall. On Memorial Day 1893, the city unveiled the monument in the triangle at Cookman and Grand Avenues. The dedication was led by Cmdr. H. L. Hartshorne of the New Jersey Department, Grand Army of the Republic. The granite base and shaft were donated by George W. Potts of Ocean Grove. The bronze figure of a Union soldier at parade rest was sometimes referred to as "old George Potts." This card was postmarked on August 27, 1907.

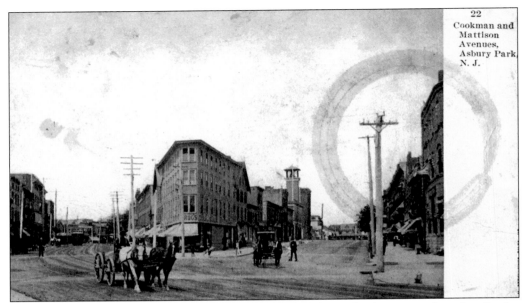

COOKMAN AND MATTISON AVENUES. This *c.* 1900 card shows the downtown shopping district, which featured many stores and businesses. The streets were unpaved, but the utility poles held the wires that electrically lit the buildings. The building on the corner between the two streets resembles the Flatiron Building in Manhattan. In the middle background on right is the bell tower of the Wesley Fire Company.

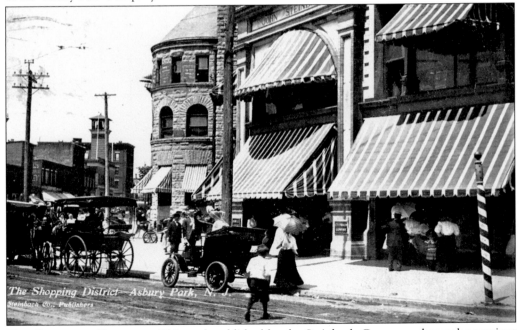

THE SHOPPING DISTRICT. This card, published by the Steinbach Company, shows the awnings at the front of Steinbach's on the right, as well as the rounded façade of the post office building to the left of the store. The upper floors of the post office were the locations of two New York newspaper offices. Also visible is the Wesley bell tower. The postmark is August 18, 1908.

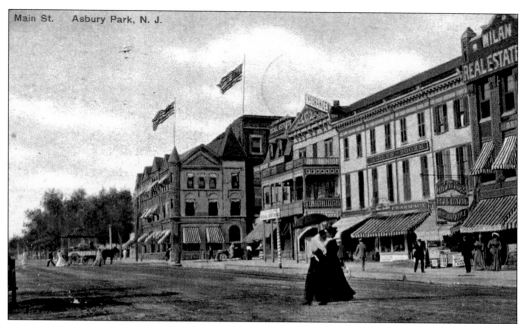

Main St. Asbury Park, N. J.

MAIN STREET. This view of Main Street shows the businesses across the street from the railroad station. There are two big real-estate offices and a couple of insurance company buildings, evidence that the construction and investment in Asbury Park real estate were big business. The postmark on this card is July 24, 1910.

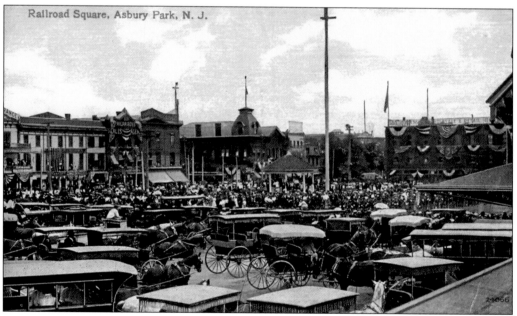

Railroad Square, Asbury Park, N. J.

RAILROAD SQUARE. Three of the buildings from the previous postcard are shown here, as the viewer also takes in the railroad station's busy parking lot, congested with many horses and carriages. There is a gazebo in the center of the parking lot, and all the buildings are dressed with patriotic bunting to celebrate either Memorial Day or the Fourth of July.

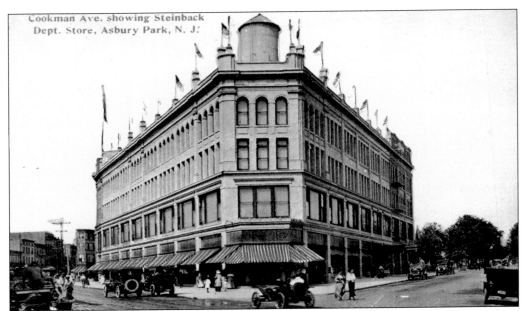

COOKMAN AVENUE SHOWING STEINBACK DEPARTMENT STORE. Dated September 12, 1913, and misspelling the store's name, this postcard shows the original department store, which was four stories tall and had a water tower on the roof. In 1910, Steinbach's (at Cookman and Bangs Avenues) extended along the westerly end of the block. In 1896, John and Jacob Steinbach bought the Commercial Hotel, and the emporium became a mammoth department store. When Asbury Park was incorporated in 1897, the brothers timed the opening of their new store to coincide with celebrations marking the city's independence from Ocean Township.

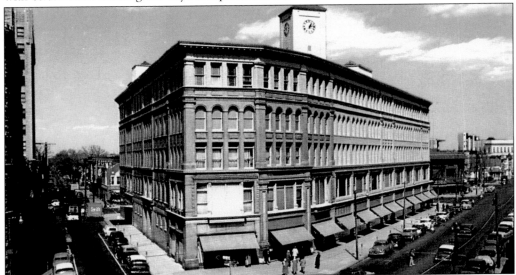

UNTITLED. Postmarked August 29, 1956, this card shows the altered Steinbach's. A fifth floor has been added, and a clock tower has replaced the water tower. On the reverse of the postcard is an advertisement: "Steinbach Company, a quality department store serving the shore since 1870. The tower and clock, a landmark, can be seen from 17 miles at sea." Signed by R. J. Goerke Company (which bought Steinbach's in the 1950s), the card ends with this: "It's an associate store of ours."

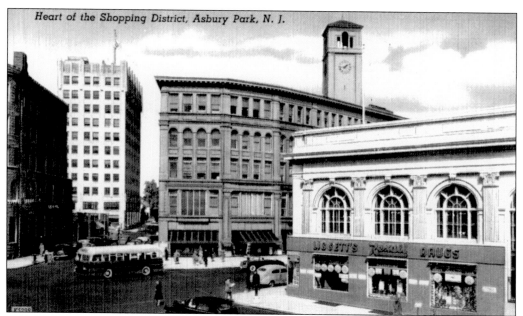

Heart of the Shopping District, Asbury Park, N. J.

HEART OF THE SHOPPING DISTRICT. This *c.* 1945 postcard shows businesses on Cookman Avenue as viewed from Press Plaza. The drugstore, on right, occupies what used to be a bank building. Steinbach's is across the street, at center. The former post office stands at far left, across Emory Street, with the 11-story New Jersey Natural Gas building behind it.

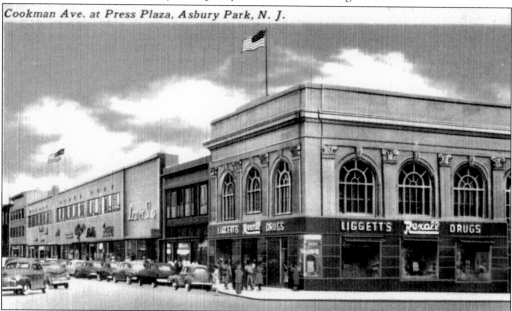

Cookman Ave. at Press Plaza, Asbury Park, N. J.

COOKMAN AVENUE AT PRESS PLAZA. In 1895, J. Lyle Kinmouth bought the *Daily Press* and renamed it the *Asbury Park Press.* After the death of Kinmouth in 1945, the city officially adopted the name Press Plaza for the square formed by the junction of Cookman Avenue, Mattison Avenue, and Emory Street. The *Asbury Park Press* radio station, WJLK (Kinmouth's initials), went on the air in 1947.

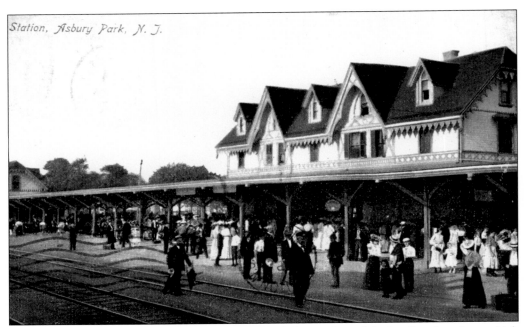

STATION, Asbury Park, N. J.

STATION. Dated September 4, 1908, this postcard shows the original railroad station, which was razed in 1922. A new, larger railroad station was erected to handle the commuters and the summer visitors.

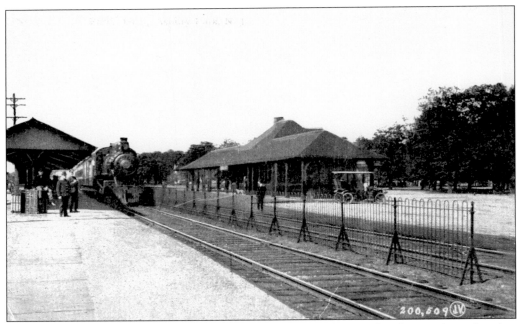

200,509

NORTH ASBURY PARK DEPOT. Dated November 9, 1912, the North Asbury train station, just one stop before the main station, served the mostly residential clientele who lived in the summer cottages or big summer hotels and boardinghouses.

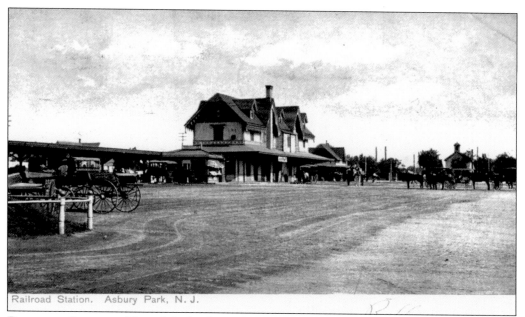

Railroad Station. Asbury Park, N. J.

RAILROAD STATION. The original railroad station is shown on this card, which bears a postmark of August 25, 1909.

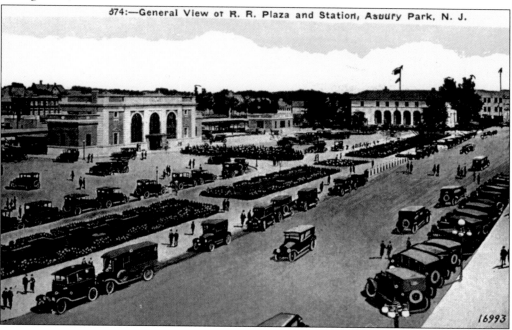

574:—General View of R. R. Plaza and Station, Asbury Park, N. J.

16993

GENERAL VIEW OF RAILROAD PLAZA AND STATION. Built in 1922, the palatial railroad station, at left, easily handled many commuters and vacationers efficiently. The parking lot in front of the station may have been reserved for short-term parking for picking up and delivering passengers. The row of cars on Main Street, backed into parking spaces, may be cabs waiting for the arrival of the next train from New York. The new post office building is shown on the right, facing the plaza.

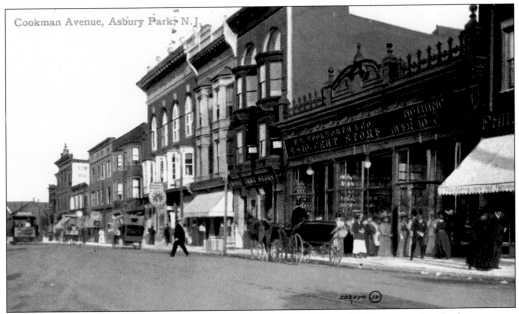

COOKMAN AVENUE. This postcard shows the Cookman Avenue businesses and a clock on a post on the sidewalk. The store in the foreground is Woolworth and Company, a dealer in inexpensive clothing and linens for the general public. There were several five-and-dime stores along this stretch of Cookman Avenue. The postmark on this card is February 28, 1911.

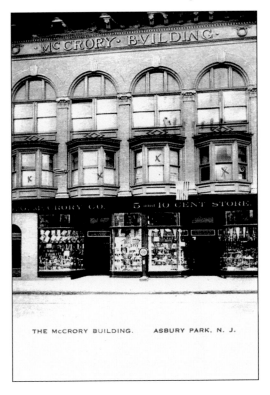

THE McCRORY BUILDING. This is a view of another five-and-dime store on Cookman Avenue, McCrory's. For some reason, four of the second-floor windows are marked with X. They may have been offices or apartments. The card was postmarked in May 1922.

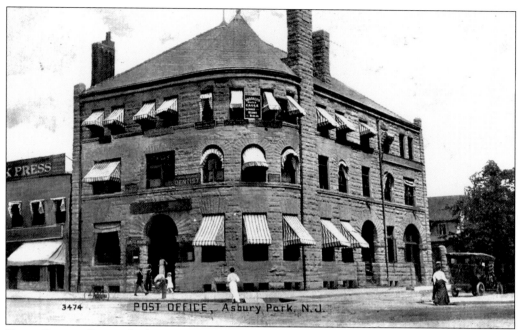

POST OFFICE. Postmarked on October 7, 1907, this card shows the post office that occupied the first floor of the former bank building. The upper floors were leased by the *New York Times* and the *Brooklyn Eagle*, both of which had summer offices so as to be "on the scene" when anything happened in Asbury Park.

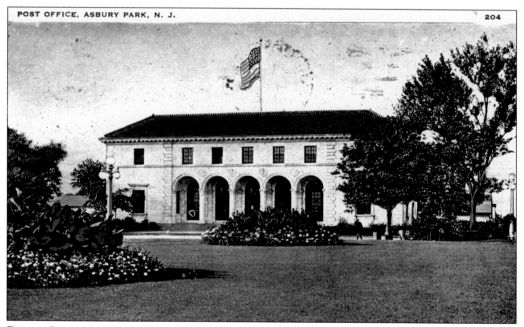

POST OFFICE. Postmarked on July 15, 1926, this card shows a completed post office building. An addition was made to the building in 1934, and since then, no other expansions have been made.

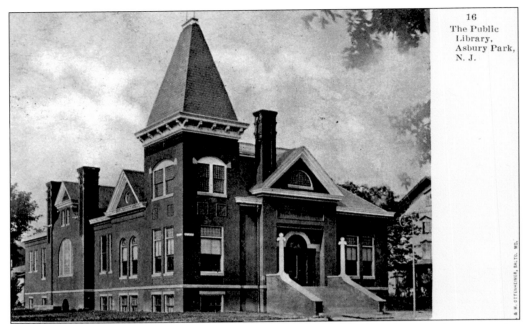

THE PUBLIC LIBRARY. There were 500 library members in 1882, when the group began meeting in the YMCA. Founder James A. Bradley and his wife, Helen Packard Bradley, were instrumental in getting the library construction started in 1882. Due to funding problems, the library was not finished until 1901. The Ariel Club raised money for the new library and continued to give support through the years. The late Wayne D. McMurray, publisher and editor of the *Asbury Park Press*, gave financial support to the library over many decades.

UNTITLED. In 1930, the tower, gable, and chimney of the public library were removed. In August 1886, a huge stained-glass window (dedicated to Pres. Ulysses S. Grant and donated by George W. Childs in honor of the deceased hero of Appomattox) was viewed by Grant's widow, Julia, and their son Col. Fred Grant.

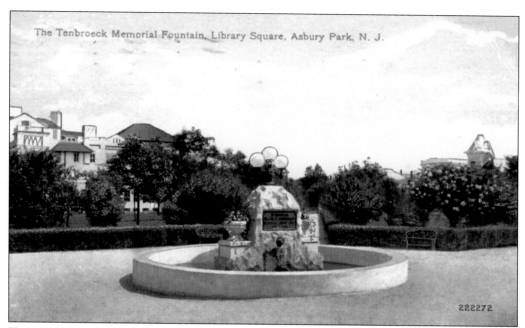

THE TEN BROECK MEMORIAL FOUNTAIN, LIBRARY SQUARE. The fountain is dedicated to the memory of the city's first mayor, Frank Ten Broeck, who served from 1898 to 1901. Ten Broeck's fountain is in the middle of Library Square on Grand Avenue, between First and Asbury Avenues, across the street from the public library. The postmark on this card is August 27, 1917.

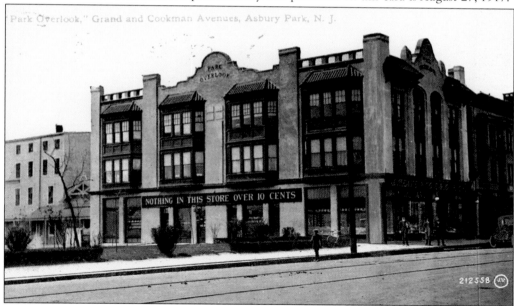

PARK OVERLOOK, GRAND AND COOKMAN AVENUES. The postcard shows just one of the many "pocket" parks that were located throughout the city. James A. Bradley wanted to have many parks for the public to enjoy at any time of the year. The pocket park seen here, at lower left, was next to a building named Park Overlook. The sign posted on the building claims, "Nothing in this store over 10 cents." This card bears a postmark of August 18, 1910.

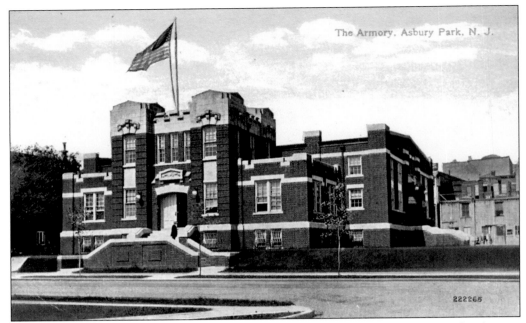

THE ARMORY. Built in 1908, the armory was home to the 114th Infantry Regiment. Servicemen left from the armory to go to World Wars I and II. In 1968, the building became the home of the Veterans of Foreign Wars (VFW) Post No. 1333.

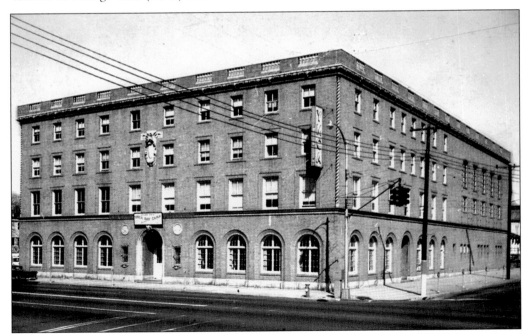

UNTITLED. On November 3, 1908, the Young Men's Christian Association (YMCA) purchased the former opera house at 509 Sewell Avenue. It was the largest YMCA in the United States, per population. It contained 62 resident rooms, two gyms, a swimming pool, and a four-wall handball court. The building's entrance was moved to 600 Main Street.

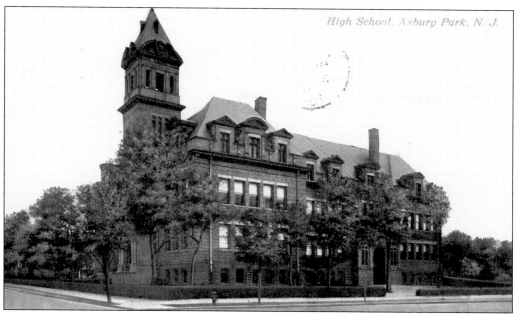

High School, Asbury Park, N. J.

HIGH SCHOOL. Built in 1877 at a cost of $10,000, the original wooden high school was built on Bond Street, and served the city and some surrounding districts. The school featured eight classrooms in the front. Later additions added more classrooms. When the new high school was built, the old school was moved around the corner, facing Monroe Avenue, and became the Bond Street Elementary School. The postmark on this card is August 16, 1915.

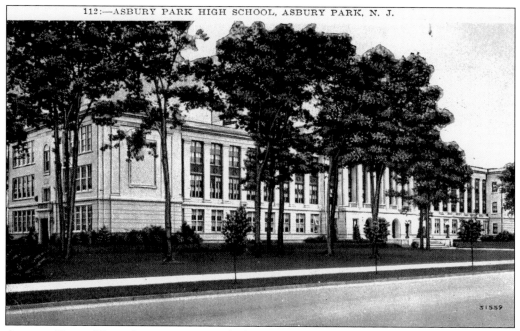

112:—ASBURY PARK HIGH SCHOOL, ASBURY PARK, N. J.

31559

ASBURY PARK HIGH SCHOOL. Postmarked on June 30, 1929, this card shows the new high school, which was built in the 1920s on Sunset Avenue, west of Main Street.

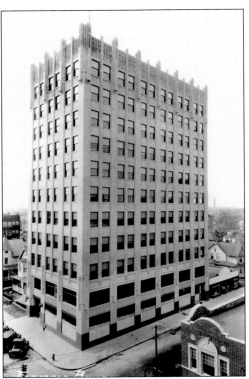

ELECTRIC BUILDING. This building was erected by the Eastern New Jersey Power Company in 1927 at the corner of Bangs Avenue and Emory Street. On the main floor, showrooms displaying new electric appliances were intermingled with the business offices. The upper floors in the 12-story building were used for offices.

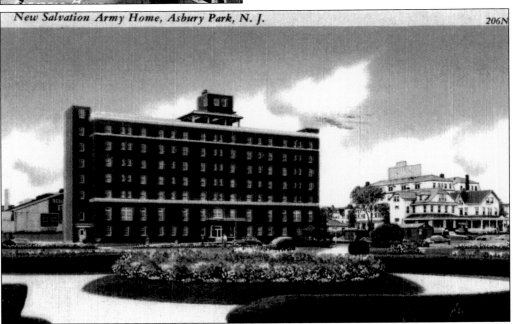

NEW SALVATION ARMY HOME. Located at 210 Fifth Avenue, this seven-story building served as a retired officers' home. It was the only retirement residence for Salvation Army officers in the United States. In 2003, the building was sold to the Teicher Organization, developers from East Brunswick, New Jersey. This card bears a postmark of August 23, 1958.

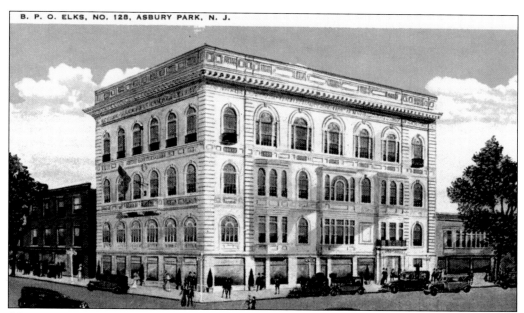

BPO ELKS, NO. 128. Erected in 1914 on the corner of Heck and Monroe Avenues by the Elks and renovated in 1924, the building was sold in the 1940s and later became the Charms Building. After that, it became the M&K Lounge. Charles Fitkin, for whom the Neptune hospital was named, was a charter member of the Elks. In 1922, the membership voted to devote time and funds to help handicapped children. A walk-in clinic was opened in the lodge and was staffed with medical personnel.

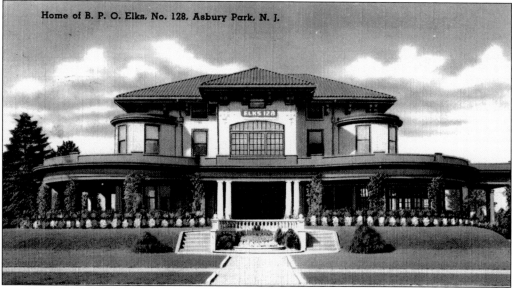

Home of B. P. O. Elks, No. 128, Asbury Park, N. J.

HOME OF BPO ELKS, NO. 128. The Elks membership moved into this building on the corner of Park and Eighth Avenues. It had previously been the Morgan family home. After more than 60 years in this building, the members sold the property to private parties in February 2001, and moved the Elks headquarters to Neptune Township. The Elks' latest home, on West Bangs Avenue, was formerly the Stage Coach Inn. The postmark on this card is July 30, 1945.

ASBURY PARK AND OCEAN GROVE BANK. Located on Mattison Avenue at the northeast corner of Main Street, the Asbury Park and Ocean Grove Bank was organized in 1889, with branches in Ocean Grove and Neptune. Built by Robert A. Tusting for his piano business, the structure was purchased in 1889 by the bank when it was newly organized. Tusting's piano building was moved to make way for the bank's second building at that location. Tusting's original building now stands at 709–711 Bangs Avenue.

Sea Coast National Bank, Asbury Park, N. J.

SEA COAST NATIONAL BANK. The Central Fruit and Market Stand, on the southeast corner at Cookman Avenue and Emory Street, was replaced by the Sea Coast Trust Company in 1922. Sea Coast was organized as a national bank in 1903 at 208 Main Street, with $50,000 in capital, a $50,000 surplus, and resources at the end of it first year of $313,741. The bank became a trust in 1916. This card was postmarked on March 29, 1911.

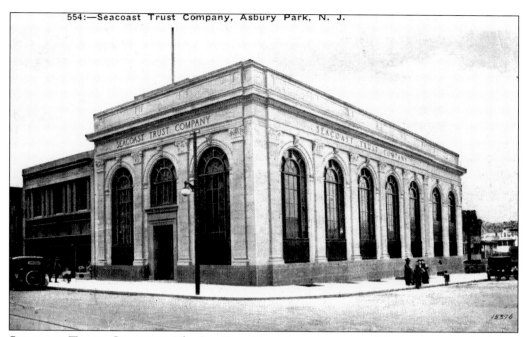

554:—Seacoast Trust Company, Asbury Park, N. J.

SEACOAST TRUST COMPANY. The Sea Coast Trust Company opened for business on Cookman Avenue in 1922.

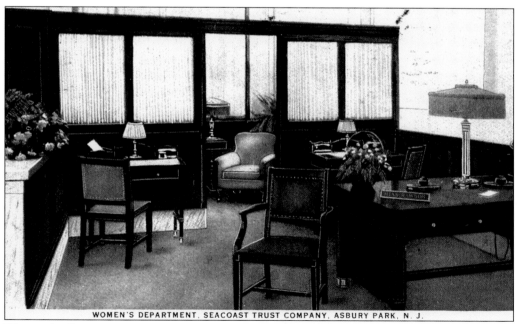

WOMEN'S DEPARTMENT, SEACOAST TRUST COMPANY, ASBURY PARK, N. J.

WOMEN'S DEPARTMENT, SEACOAST TRUST COMPANY. In April 1912, the bank opened a separate women's department. L. Mae Rawson, vice president, was in charge. At this location, the bank also had a vault for furs. The postmark on this card is April 26, 1933.

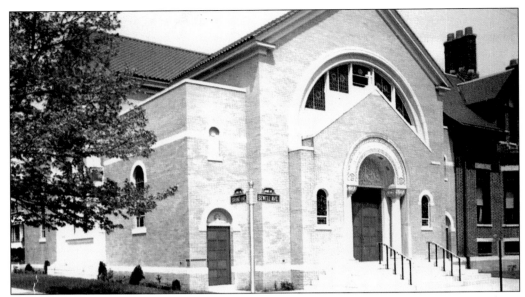

UNTITLED. St. George Orthodox Church, established in 1929 and located at the northeast corner of Grand and Sewell Avenues, is shown in this postcard. The church was built on the site of the Wheelman's Club house, which served as a USO site for the World War II servicemen in the area. The Wheelman's Club, organized in 1890, sponsored bicycle races in different locations around Asbury Park. At its peak, the club had 600 members, but by the mid-1940s, the club, in decline, became the USO for area servicemen. The St. George Orthodox Church was built after World War II in the front yard of the former Wheelman's Club after substantial alterations and construction of new buildings.

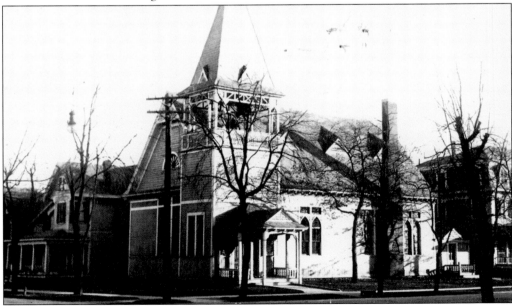

REFORMED CHURCH. The Dutch Reformed church on the southeast corner of Sewall and Grand Avenues was established on July 10, 1898. It was later used by the city as a public school facility. It was acquired by Temple Beth El in the early 1920s.

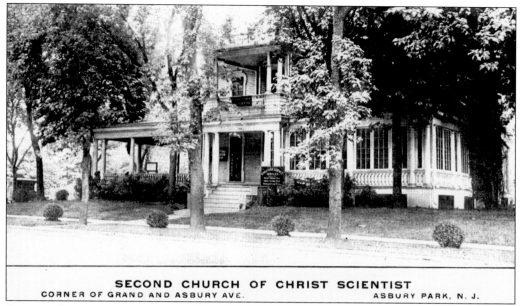

SECOND CHURCH OF CHRIST SCIENTIST
CORNER OF GRAND AND ASBURY AVE. ASBURY PARK, N. J.

SECOND CHURCH OF CHRIST SCIENTIST. This church merged with the First Church of Christ, Scientist, on the corner of Third Avenue and Emory Street. The new church is on the corner of Grand and Asbury Avenues and is now named the Cathedral Assembly by the Shore.

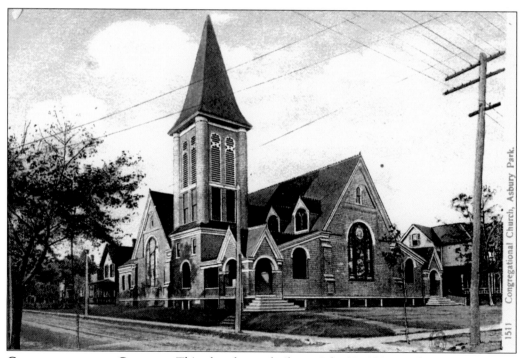

CONGREGATIONAL CHURCH. This church was built on July 10, 1898, at the corner of First Avenue and Emory Street, on land donated by founder James A. Bradley. In the 1920s, it was acquired by Temple Beth El.

123

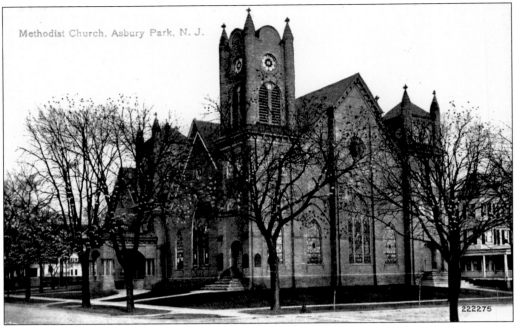

Methodist Church, Asbury Park, N. J.

222275

METHODIST CHURCH. Built in 1883 on land donated by founder James A. Bradley on the east side of Grand Avenue between First and Second Avenues, the Methodist church was razed in 1917 by a huge fire that destroyed four city blocks west of the boardwalk. The church was replaced by a red-brick Byzantine-style structure.

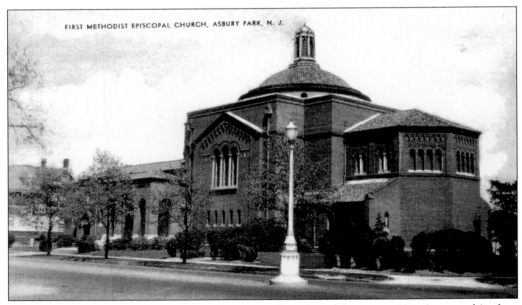

FIRST METHODIST EPISCOPAL CHURCH, ASBURY PARK, N. J.

FIRST METHODIST EPISCOPAL CHURCH. Located on Grand Avenue at First Avenue, this place of worship became a United Methodist church after a merger under the United Brothern in the 1950s.

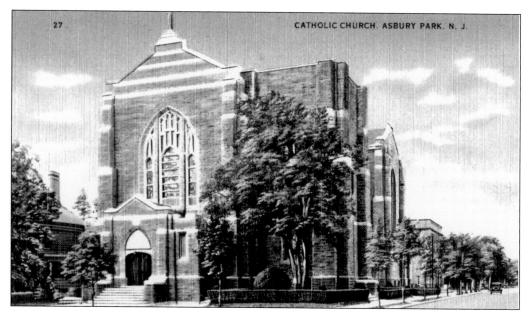

CATHOLIC CHURCH. The Church of the Holy Spirit, on the northwest corner of Second Avenue and Bond Street, was constructed between 1909 and 1912 in the Late Gothic Revival style. Philadelphia architect George Lovatt designed the stone exterior foundation from Holmsburg granite with Indiana limestone trim. The gable roof and pointed tracery with stained-glass window in the large tower on the southeast corner set off the Tudor-arch, strap-hinged wooden doors in pointed-arch enframements.

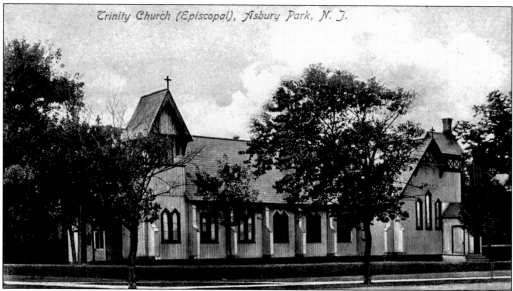

Trinity Church (Episcopal), Asbury Park, N. J.

TRINITY CHURCH (EPISCOPAL). In 1875, the first church to be built in Asbury Park was on the corner of Grand and Asbury Avenue on land donated by James A. Bradley. In 1906, a stone church was built, and the original wooden church became the parish house, which burned to the ground in 1938. The first stone church was replaced by the present building and was moved to the corner of Ridge and Springwood Avenues to become St. Peter Claver Roman Catholic Church.

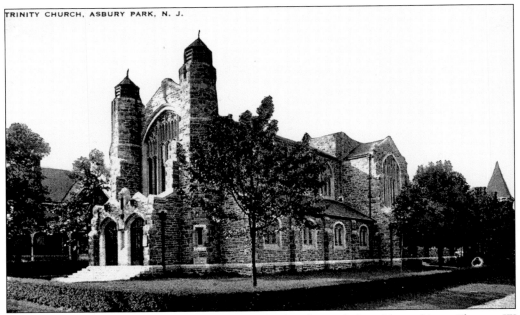

TRINITY CHURCH. The present Trinity Episcopal Church was designed by architect Clarence W. Brazer of Philadelphia. The church was dedicated on July 10, 1910.

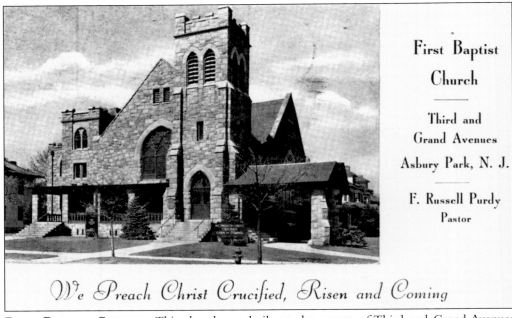

First Baptist
Church

Third and
Grand Avenues

Asbury Park, N. J.

F. Russell Purdy
Pastor

We Preach Christ Crucified, Risen and Coming

FIRST BAPTIST CHURCH. This church was built on the corner of Third and Grand Avenues on property donated by James A. Bradley. It was established to serve an all-white congregation. In 1891, the Second Baptist Church, an all-black church, was organized in a building on Atkins Avenue near Springwood Avenue. This card was postmarked on July 12, 1939.

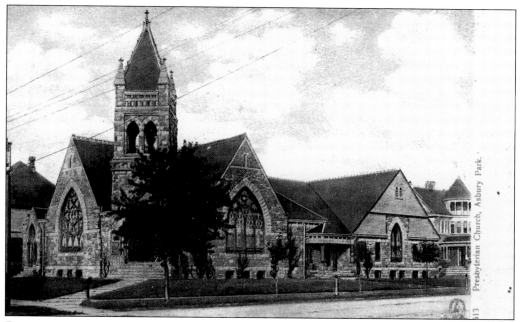

Presbyterian Church, Asbury Park.

PRESBYTERIAN CHURCH. A wooden church was built in 1884 on land donated by James A. Bradley at the corner of Grand and Second Avenues. In 1893, a new church was built of Philadelphia quarry stone to replace the wooden one. Three huge stained-glass windows showing biblical themes were a big attraction. In 1979, fire destroyed the building, and the lot remains vacant to this day. The postmark on this card is July 29, 1907.

UNTITLED. Asbury Towers, a nonsectarian residence for senior citizens, was sponsored by the Presbyterian Homes of New Jersey. The 26-story, 350-unit apartment building was located at 1701 Ocean Avenue, at Eighth Avenue.

UNTITLED. Paul Samperi's Restaurant and Cocktail Lounge, which claimed it was the shore's finest restaurant, was located on Route 35 at the Asbury Park Circle. The restaurant was open all year for luncheon and dinner. American and Continental cuisine were available, and facilities were offered for private parties.

UNTITLED. Published by Steinbach's to celebrate the country's bicentennial in 1976, these postcards were on sale at the store. The reverse advertisement reads: "Steinbach 1870–1976. Our bicentennial postcards are available for purchase at all Steinbach service desks." The billboard was erected on Route 35 at the Asbury Park Circle.